LOUVRE ABU DHABI

Louvre Abu Dhabi would like to express its sincere gratitude to those who have been involved in the Louvre Abu Dhabi project and have directly contributed to the constitution of the collection:

H.E. Mohamed Khalifa Al Mubarak,
H.E. Saif Saeed Ghobash,
H.E. Zaki Anwar Nusseibeh,
H.E. Omar Saif Ghobash,
H.E. Noura Mohamed Al Kaabi,
H.E. Sheikh Sultan Bin Tahnoon Al Nahyan,
H.E. Mubarak Hamad Al Muhairi,
H.E. Saeed Al Hajeri,
Rita Aoun-Abdo, Jean-Luc Martinez,
Henri Loyrette, Pierre Rosenberg,
François Baratte, Marie-Claude Beaud,
Peter Fuhring, Antoine Gournay,
Jean-François Jarrige†, Francis Richard,
Gilles Veinstein†, Jean-François Charnier,
Laurence des Cars, Emmanuel Coquery,
Olivier Gabet, Manon Six, Vincent Lefèvre,

Christine Macel, Olivia Bourrat,
Noëmi Daucé, Souraya Noujaim,
Guilhem André, Juliette Singer,
Sébastien Delot, Matthieu Thénoz,
Tehzeeb Sandhu, Louise Delestre,
Alia Zaal Lootah,
Khalid Abdulkhaliq Abdulla,
Rana Mohammed Al Hammadi,
Mohamed Abdulla Al Mansoori,
Adrien Berthelot, Jérôme Delaplanche,
Anne Coron, Estelle Guéville,
Elisabeth Maratier, Elodie Jeannest,
Nourane Ben Azzouna,
Alessandra Fiorentini,
Sylphide de Daranyi

LOUVRE ABU DHABI

MASTERPIECES OF THE COLLECTION

LOUVRE ABU DHABI

SKIRA

FOREWORD

It is no exaggeration to say that we are bearing witness to a pivotal moment in the history of museums. The opening of Louvre Abu Dhabi not only marks the completion of a building of stunning architectural complexity and the amassing of a collection of global significance; it also represents the advent of the very concept of the museum, as invented in Enlightenment Europe, into the Arab world for the first time.

The initial seed for Louvre Abu Dhabi was planted ten years ago. It took the form of an intergovernmental agreement, signed between the United Arab Emirates and France on 6 March 2007. On that day, the two governments agreed to create a new museum in Abu Dhabi, the capital city of the United Arab Emirates, a country whose outstanding dynamism is a central element of the contemporary world. This new museum would celebrate the universal stories of humanity and it was called Louvre Abu Dhabi.

At the heart of the museum is the shared idea of a flourishing national community confident in itself, its culture and its origins. Since its inception, the country has always been characterised by a spirit that is open to the world. The continuing opening-up of the country shows to the world that this is a place of hospitality, as well as a seat of dialogue between different ideas and civilisations. As part of this process, Louvre Abu Dhabi builds upon the vision of the late Sheikh Zayed bin Sultan Al Nahyan, the driving force behind the creation of the United Arab Emirates in 1971.

Many have been instrumental in seeing Louvre Abu Dhabi to fruition. Special tribute must be paid to the vision of His Highness Sheikh Khalifa bin Zayed Al Nahyan, President of the United Arab Emirates, and His Highness Sheikh Mohammed bin Zayed Al Nahyan, Crown Prince of Abu Dhabi and Deputy Supreme Commander of the UAE Armed Forces. Together, they envisioned the creation of Louvre Abu Dhabi so that the United Arab Emirates would be numbered among the great cultural nations of the world. This far-sighted ambition stems from an intuitive understanding of the power of culture to stimulate development across all fields of society: as much economic and educational as creative.

In France, a tribute must be paid to the men and women who immediately embraced this exceptional project, taking the risk to participate in what had never been accomplished previously, including the different Ministers of Culture who brought and supported this ambition, and of course Henri Loyrette, President-Director of the Louvre museum when the intergovernmental agreement was signed.

For Louvre Abu Dhabi, France is delighted to share the excellence of its *savoir-faire*: its expertise in museology, curating and culture. Together, the two nations have embarked on

the creation of a fundamentally innovative museum that will become a reference point across the world and for the future. Louvre Abu Dhabi was never going to be a simple adjunct to the Parisian original, a little Louvre in Abu Dhabi. Instead, it was necessary to create a museum with its own unique identity: a universal museum, telling the stories that have united humans beyond the restrictions of time and place. For example, the vision of Abu Dhabi as a welcoming and meeting place for different cultures and religions prompted the curators to remove the partitions between collections and induce new connections between the different arts. In this way, Louvre Abu Dhabi also reflects and shapes what is now such an interconnected world.

Louvre Abu Dhabi offers an unprecedented opportunity to provide an interdisciplinary presentation of France's public collections, to show them to new people in new ways. To this end, the Musée du Louvre has partnered with some of France's most prestigious cultural and heritage institutions: Centre Pompidou; Musées d'Orsay et de l'Orangerie; Bibliothèque nationale de France; Musée national des Arts asiatiques – Guimet, Musée du quai Branly – Jacques Chirac; Château, musée et domaine national de Versailles; and Musée Rodin. In addition, the circle of institutions loaning works has expanded to include: Musée de Cluny – Musée national du Moyen Âge; Cité de la céramique – Sèvres & Limoges; Musée des Arts Décoratifs; Musée d'Archéologie nationale de Saint-Germain-en-Laye; and Château de Fontainebleau. The three hundred loans agreed by these institutions will complement the six hundred acquisitions already made by Louvre Abu Dhabi for its own collection. Together, these will form the museum's hugely impressive opening presentation.

Before readers become caught up in the diverse, complex and inspiring stories, we would like to extend our heartfelt thanks to the teams at Louvre Abu Dhabi who have worked with complete commitment since 2007 to bring this exceptional project to life.

H.E. Mohamed Khalifa Al Mubarak
Chairman of the Department of Culture and Tourism

Jean-Luc Martinez
President-Director, Musée du Louvre

THE CREATION OF A MUSEUM'S COLLECTION FROM NOTHING in just a few years is a challenge that many would have called impossible. To bring this project to a successful conclusion, two elements were required: the vision held by Abu Dhabi, implemented by the Department of Culture and Tourism and the Louvre Abu Dhabi team, and the professional expertise of the museums represented by the Agence France-Muséums.

This album of the Louvre Abu Dhabi collection of works allows readers to fully enjoy what the museum offers its visitors: an encounter with the universal across epochs, cultures and civilisations. The discovery – or rediscovery – of the works exhibited in the Louvre Abu Dhabi is a unique experience: on one hand because they are seen in a new light, that of Abu Dhabi filtered through the dome designed by Jean Nouvel, and on the other because their dialogue with works with which they are not usually presented increases their polysemy. This album provides a key to understanding the characteristics common to all humanity and the elements that constitute and form our distinct identity filtered through the prism of time, culture and history. The museum's presentation thus conveys to each visitor that the globalisation of civilisation should be viewed with perspective, and understood as an opportunity in a world undergoing constant change.

What more stimulating challenge could there be for the French institutions represented by the Agence France-Muséums than to invent, in partnership with the Louvre Abu Dhabi and the Department of Culture and Tourism, a museum entirely unlike any other in existence? So remarkable has their commitment to this project been that they must be mentioned by name: the Musée du Louvre, the Musées d'Orsay et de l'Orangerie, the Centre Pompidou, the Musée du quai Branly – Jacques Chirac, the Musée national des Arts asiatiques – Guimet, the Bibliothèque nationale de France, the Réunion des musées nationaux – Grand Palais, the Château de Versailles, the Musée de Cluny – Musée national du Moyen Âge, the Musée Rodin, the Arts Décoratifs, the Cité de la céramique – Sèvres & Limoges, the Musée d'Archéologie nationale à Saint-Germain-en-Laye, the Château de Fontainebleau, the École du Louvre, the domaine national de Chambord, and the Opérateur du Patrimoine et des Projets Immobiliers de la Culture (OPPIC).

Brought together by the Louvre Abu Dhabi, the United Arab Emirates and France remind us that culture and education remain invaluable foundations that this museum, now open to one and all, embodies in so many ways.

Marc Ladreit de Lacharrière
President of the Agence France-Muséums

WE VISIT MUSEUMS FOR MANY REASONS. To discover the past or to marvel at beautiful things. To witness the power of genius or simply to restore our spirits.

Louvre Abu Dhabi combines these familiar elements, then frames them in the larger context of our common human experiences. By doing so, it aspires to be a universal museum, the first in the Arab world.

The collection of the Louvre Abu Dhabi is universal in its scope: from prehistory to the latest contemporary commissions. Artists Giuseppe Penone and Jenny Holzer have created new works in direct response to the museum's unique architecture and spirit. The very first purchase was made in 2009: a seminal painting by abstract pioneer Piet Mondrian. Since then, the collection has expanded to over 600 pieces. The diversity of masterpieces is astonishing. Highlights include an incredibly rare Bactrian princess from the 3rd millennium BCE; a 3000-year-old Middle-Eastern gold bracelet; and a magnificent monumental bronze lion from Andalusia from the 11–12th century.

Alongside these are works by some of the great European masters of the 19th and 20th centuries: Paul Gauguin, Pablo Picasso, Paul Klee and René Magritte. A series of nine canvases by Cy Twombly produced in Italy just three years before the artist's death in 2011 is also on show. Together, such works, and many more, represent the human desire for artistic expression in its entirety.

This is also a museum of universal influences. Artists have always drawn inspiration from other cultures, even if their lives may be separated by many centuries. Located now in Abu Dhabi, a crossroads of different civilisations, these works demonstrate the interconnection of ideas and techniques that result from global networks of communication and exchange. Many fascinating themes recur throughout the museum: birth and death, religion, power, nature and the human body. There are textiles and ceramics, sculptures and photography, illuminated manuscripts, jewellery, tools, tiles, furniture and some of the most beautiful paintings imaginable. Such works show the value of diversity. They also celebrate the ideas and emotions universal to all people.

Louvre Abu Dhabi shares with the world art of extraordinary beauty in a setting designed to encourage curiosity, respect and acceptance. The emotions that these works inspire are universal. This should remind us that what we have in common is far more meaningful than what we sometimes imagine sets us apart. One of art's great powers is in helping us to understand this simple truth.

Manuel Rabaté
Director of the Louvre Abu Dhabi

ACKNOWLEDGEMENTS

Louvre Abu Dhabi would like to thank all the people and institutions who have supported its opening:

Department of Culture & Tourism Management

H.E. Mohamed Khalifa Al Mubarak,
Chairman
H.E. Saif Saeed Ghobash,
Director General
Mohammad Al Frehat,
General Counsel
Nawal R. Al Hassani,
Executive Director, Strategy
Rita Aoun-Abdo,
Executive Director, Culture
Saood Al Hosani,
Acting Executive Director,
Business Support Services
Steve Copestake,
Acting Executive Director,
Marketing and Communications
Sultan Hamad Al Dhaheri,
Acting Executive Director, Tourism
Abdulaziz Mohamed Al Hammadi,
Former Acting Executive Director,
Business Support

Louvre Abu Dhabi Management

Manuel Rabaté,
Museum Director
Hissa Ali Al Dhaheri,
Deputy Museum Director
Catherine Monlouis-Félicité,
Education & Cultural Engagement Director
Douglas Masuku,
Technical Operations Director
Jennifer Francis,
Marketing, Communications
& Visitor Services Director
Marwa Rubayee Al Menhali,
Finance and Procurement Manager
Mona Khaled Al Bujairmi,
Protocol Manager
Shaima Ali Al Suwaidi,
Acting Human Resources Manager

Agence France-Muséums

Board of Agence France-Muséums

Marc Ladreit de Lacharrière,
President

Laurence des Cars,
President, Musées d'Orsay et de l'Orangerie
Laurence Engel,
President, Bibliothèque nationalc dc France
Christian Giacomotto,
President of Gimar Finance
Jean Guéguinou,
Ambassadeur de France
Sylvie Hubac,
President, Établissement public de la Réunion des musées nationaux et du Grand Palais
Serge Lasvignes,
President, Centre Pompidou
Sophie Makariou,
President, Musée national des Arts asiatiques – Guimet
Stéphane Martin,
President, Musée du quai Branly – Jacques Chirac
Jean-Luc Martinez,
President-Director, Musée du Louvre
Karim Mouttalib,
Managing Director, Musée du Louvre
Alberto Vial,
Diplomatic Advisor, Musée du Louvre

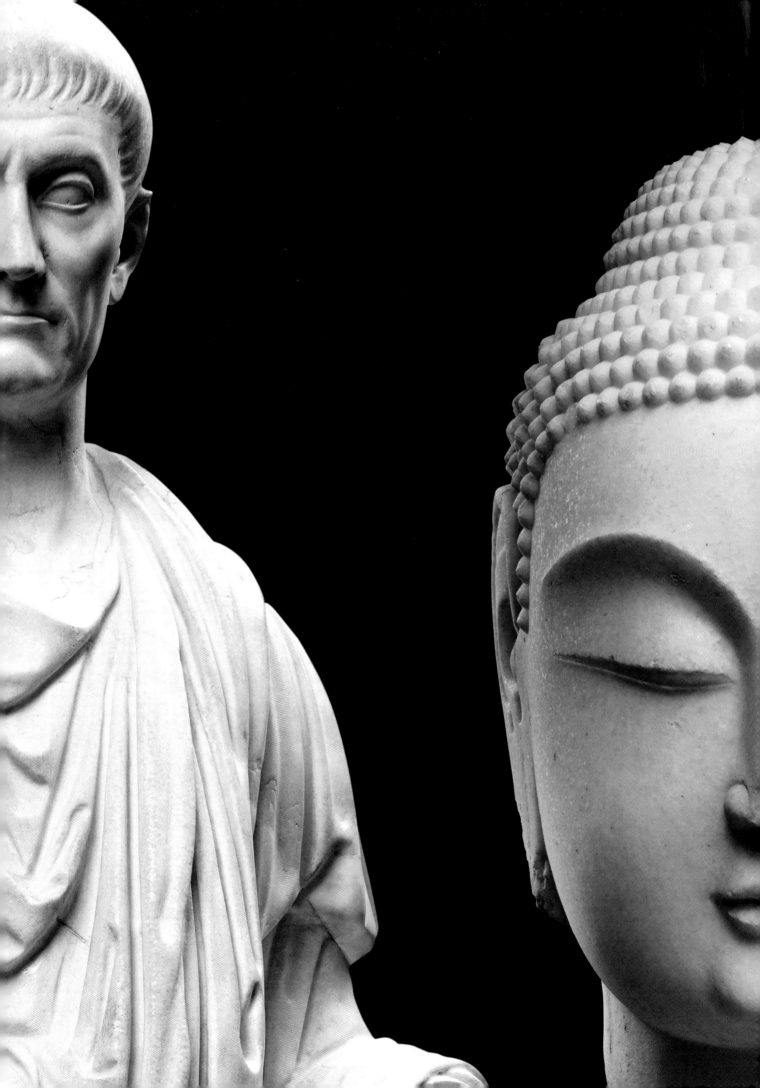

As stated by Pierre Rosenberg, honorary director of the Louvre, "A museum that does not buy is a museum that dies". The Louvre Abu Dhabi, conversely, had to buy in order to exist. It was the sale of the Yves Saint-Laurent and Pierre Bergé Collection in 2009 that enabled the museum to acquire its first works. Piet Mondrian's *Composition with Blue, Red, Yellow and Black* thus has the distinction and eternal honour of being item number one in the collection. Like Jean Nouvel's dome, this masterpiece of abstract art from the Dutch master's *Trees* series is a meditation on light, which thus commenced the adventure under the most favourable of auspices. These first acquisitions began two years after the signing on 6 March 2007 of an agreement between the governments of France and the United Arab Emirates for the creation of the universal museum, the Louvre Abu Dhabi. The agreement ratified the creation of an acquisitions committee, which has met fifteen times to date and

be accomplished at a time of increased sensitivity to the question of provenance, when items of ancient art and especially archaeology are regarded as part of the heritage and identity of the countries in which they were discovered. It appeared equally impossible to acquire works of the foremost masters and schools, as the great private collections had already been entreated assiduously by generations of museum curators. Compliance with international legislation being an absolute given for the Louvre Abu Dhabi, a different approach was required to compensate the relative paucity of works, namely artistic dialogue rather than the traditional narrative of art history and its obsession with style and genre. The idea was to open up the field of traditional icons and essential points of reference to embrace other dimensions and domains that reflect the openness of today's world and the overturning of the customary Eurocentric canons of art. At the same time, the Louvre Abu Dhabi is revealing

LOUVRE ABU DHABI
UNIVERSAL COLLECTION

made it possible to build up a collection of over 620 works between February 2009 and the opening of the museum in autumn 2017. Two exhibitions, *The Birth of a Collection* in 2009 and *The Birth of a Museum* in 2013–14, announced a collection and a museum of international standard. As becomes clear from a reading of this album, which presents the major items, and a visit to the museum, the Louvre Abu Dhabi acquisitions policy has been informed by the pursuit of quality from the very outset. The museum can pride itself on having not only purchased the finest of works but also on securing numerous masterpieces, some of which, like the *Mari-Cha Lion* and the *Winged Dragon*, are authentic icons of their civilisations and the history of art in general. The team was very much aware that it is difficult and indeed well-nigh impossible today to build up a collection with universal aspirations. In the case of the Louvre Abu Dhabi, this was also to

its own icons, like the one that adorns the cover of this publication, a *Bactrian Princess* whose mysterious beauty has survived intact for millennia. Whereas this exceptional and unprecedented broadening of the cultural spectrum endows the new museum with its universal spirit, it also gives the collection its heart and soul. The time of the primary focuses and points of reference defining the thrust of the museum's acquisitions policy will come later. The Louvre Abu Dhabi has set itself the mission of revealing the universal emotion that the masterpieces of the world's civilisations are capable of arousing. We are confident that visitors will feel the same thrill as we did on contemplating these works for the first time.

Jean-François Charnier
Scientific Director of Agence France-Muséums

THE FIRST VILLAGES

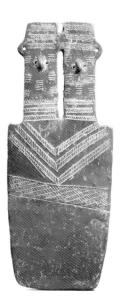

It took millions of years for the human species to spread across the globe from its place of origin in East Africa. However, around 10,000 BCE, in the Near East, China and Central America, communities settled for the first time and domesticated animal and plant species, leading to the appearance of the first villages. Despite regional differences, the first village communities seem to have shared a desire to bind their society together, by means of beliefs and rituals, around their ancestors. Human representation developed in the form of these female figurines that seem to express preoccupations with fertility. The wealth generated by profits from agriculture and livestock supported the birth of the first forms of power.

FROM TECHNOLOGY TO SYMBOLS

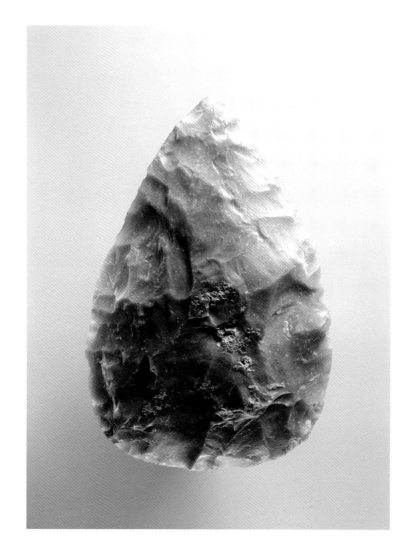

HAND AXE
France, Indre and Loire
c. 500,000 BCE

H. 20.5 cm; flint
LOUVRE ABU DHABI

BLADE IN THE SHAPE OF A LAUREL LEAF
France, Dordogne (?)
c. 22,000–18,000 BCE

H. 18.5 cm; flint
LOUVRE ABU DHABI

Page 13
PLANK IDOL WITH TWO HEADS
Cyprus
2300–1900 BCE

H. 27.9 cm; polished and incised terracotta
LOUVRE ABU DHABI

Technical prowess
produces symmetry,
which becomes a symbol
in its pointless perfection.

THE BIRTH OF THE FIGURE

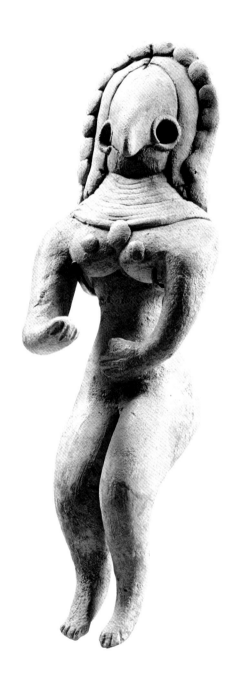

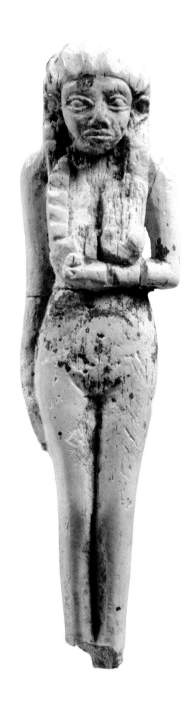

FEMALE FIGURINE WEARING A NECKLACE
Pakistan, Balochistan
2800–2700 BCE

H. 10 cm; modelled terracotta
LOUVRE ABU DHABI

FEMALE FIGURINE
Egypt, Hierakonpolis (?)
3100–2800 BCE

H. 9.5 cm; bone
LOUVRE ABU DHABI

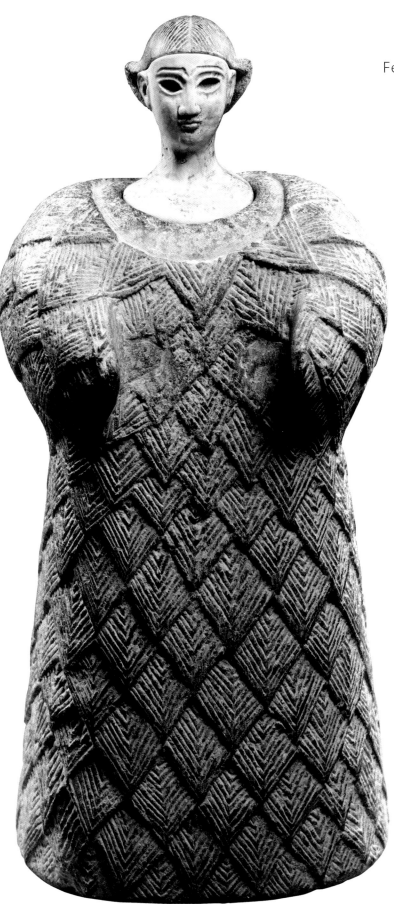

Few of the Bactrian princesses
have faces fashioned
with such finesse.

**WOMAN DRESSED IN A
WOOLLEN GARMENT**
Central Asia, Bactria
2300–1700 BCE

H. 25.3 cm; chlorite, calcite
LOUVRE ABU DHABI

THE DAWN OF POTTERY

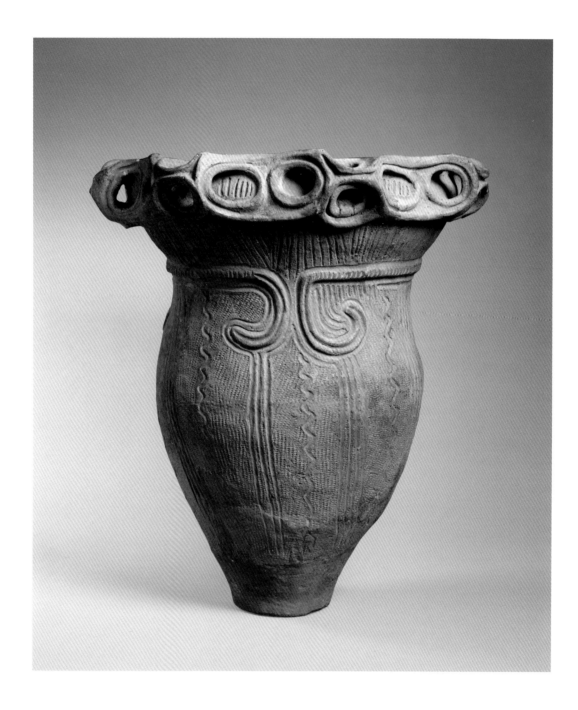

Jar with cord-patterned decoration
Japan, North Kanto
3500–2500 BCE

H. 54.5 cm; terracotta
LOUVRE ABU DHABI

THE FIRST GREAT POWERS

The first kingdoms appeared in the fertile valleys of the Tigris, Euphrates, Nile, Indus and Yellow River around 3000 BCE. The emergence of these first great powers was accompanied by the spreading use of bronze weapons. Axes, swords and armour became emblems of prestige and splendor among the powerful. The new warrior elite also began to ride horses, a development that spurred long-distance exchanges, increased the size of realms and broadened the horizons of communities. With the development of the kingdoms of Mesopotamia and Egypt came the birth of the first cities, a crucial event in the history of humanity. Resulting from a surge in population and a strong hierarchical organisation of society, the first cities became social and cultural melting pots that encouraged exchange and innovation. One fundamental invention was writing, which facilitated transactions and helped legitimise power.

IN THE TIME OF THE PHARAOHS

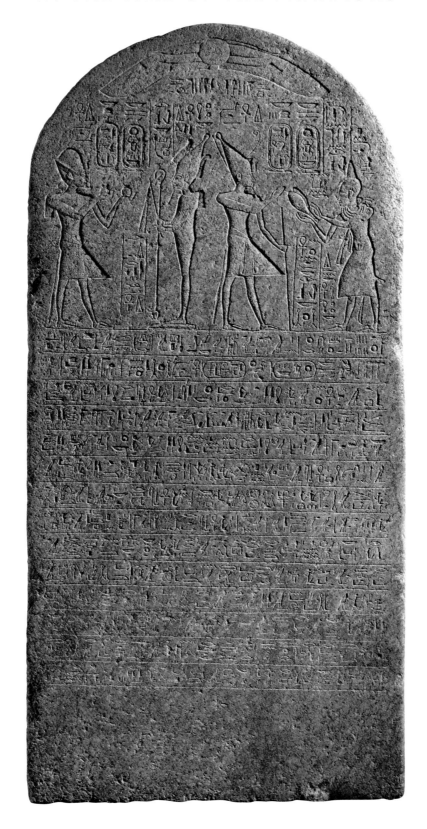

Page 19

IMAGE OF A QUEEN OR A GODDESS
Egypt
360–282 BCE

H. 19 cm; black stone

LOUVRE ABU DHABI

**STELE IN THE NAME
OF TUTANKHAMUN**
Egypt, Abydos
c. 1327 BCE

H. 166, W. 82 cm; pink granite

LOUVRE ABU DHABI

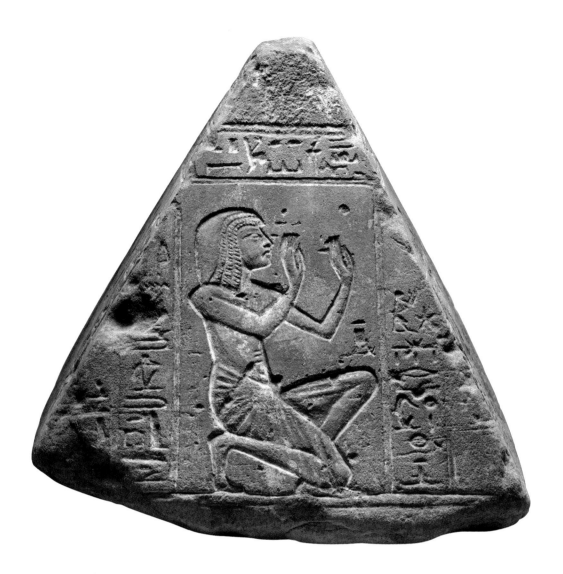

**PYRAMIDION INSCRIBED
WITH THE NAME OF HUY**
Egypt, Deir el-Medina (?)
1335–1295 BCE

H. 33 cm; sandstone
LOUVRE ABU DHABI

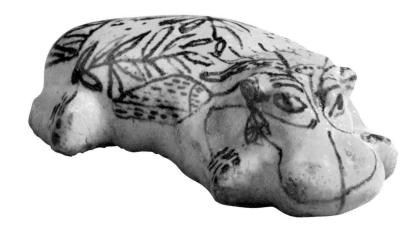

HIPPOPOTAMUS
Egypt
c. 1850 BCE

L. 14.5 cm; faience, painted decoration
LOUVRE ABU DHABI

FUNERARY PRACTICES IN EGYPT

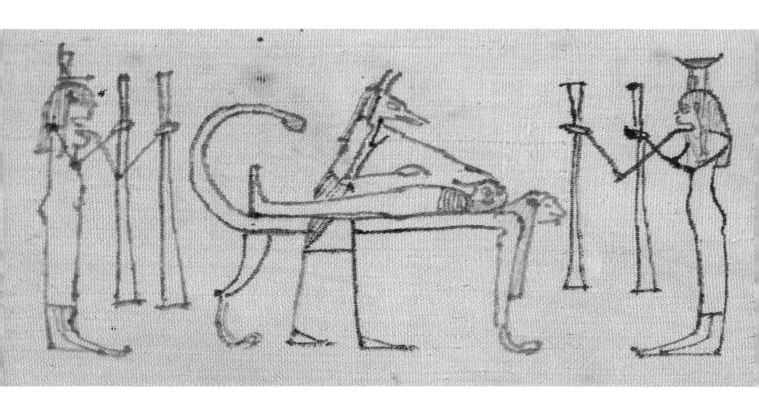

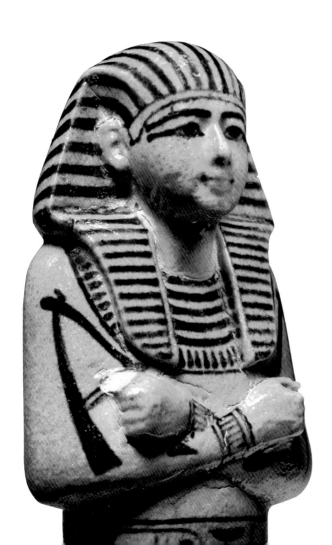

**MUMMY BANDAGE:
EXTRACT FROM THE
BOOK OF THE DEAD**
Egypt
c. 300 BCE

L. 310 cm; linen
LOUVRE ABU DHABI

**FUNERARY SERVANT
FOR PHARAOH SETI I**
Egypt, Valley of the Kings
c. 1290 BCE

H. 22.9 cm; faience
LOUVRE ABU DHABI

**SARCOPHAGUS OF
PRINCESS HENUTTAWY:
COFFINS AND MUMMY'S
WRAPPING**
Egypt
950–900 BCE

H. 180 cm; painted wood,
stuccoed and painted cloth
LOUVRE ABU DHABI

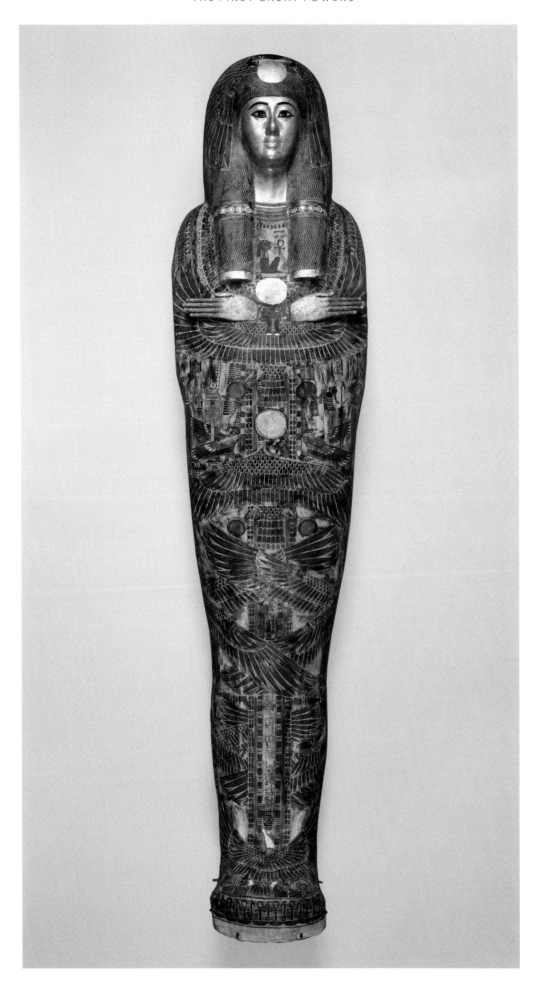

WARRIORS AND RIDERS

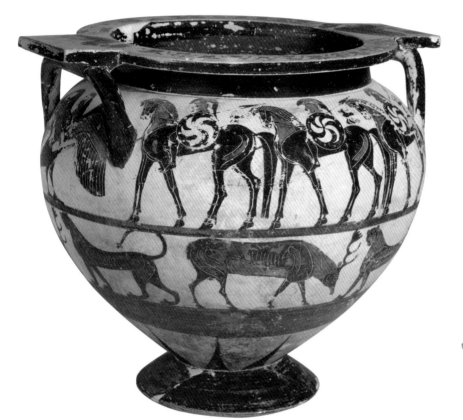

VASE: ANIMALS AND ARMED HORSEMEN
Greece, Corinth (?)
590–580 BCE

Diam. 40.5 cm; painted terracotta
LOUVRE ABU DHABI

AXE BLADE
Iran, Luristan
1000–700 BCE

H. 20.5 cm; bronze
LOUVRE ABU DHABI

Double-headed axes are symbols
of both life and rebirth
when associated with
plant motifs.

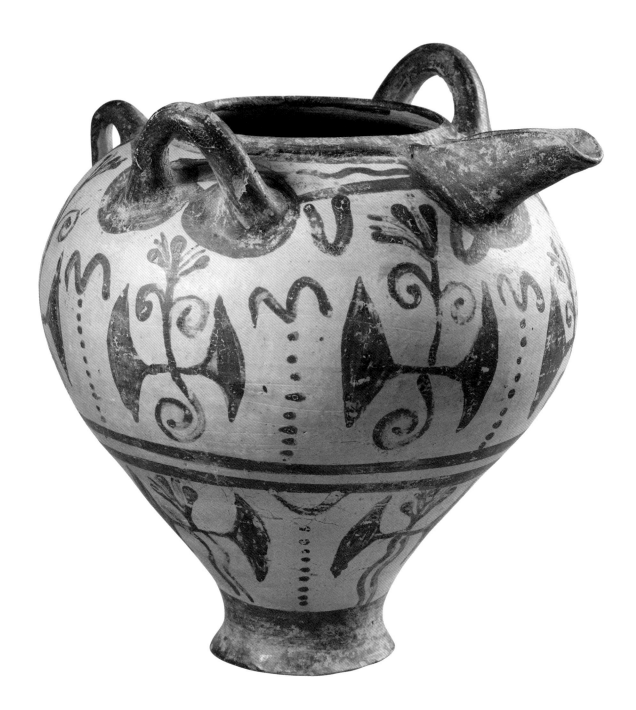

VASE WITH DOUBLE-HEADED AXE MOTIFS
Greece, Crete (?)
1500–1450 BCE

Diam. 21 cm; painted ceramic
LOUVRE ABU DHABI

GOLD TO ADORN THE BODY

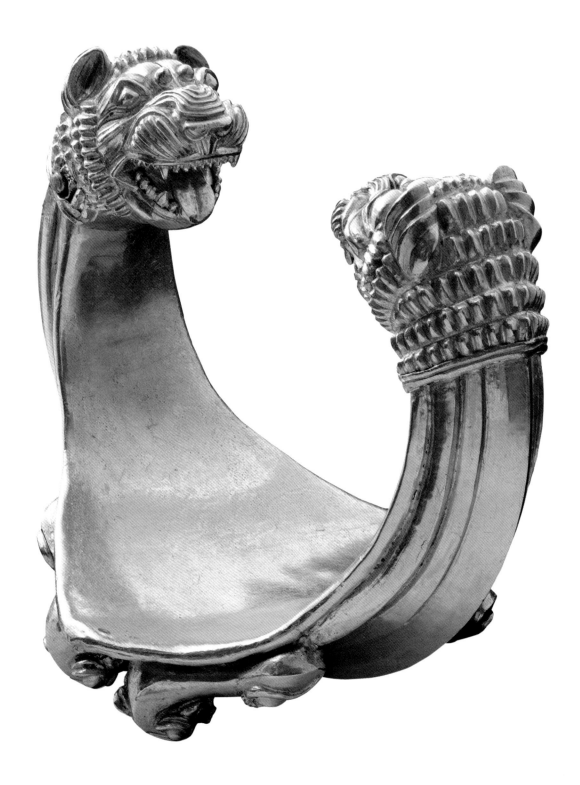

LION BRACELET
Iran, Ziwiye
800–600 BCE

Diam. 9.5 cm; gold
LOUVRE ABU DHABI

CIVILISATIONS AND EMPIRES

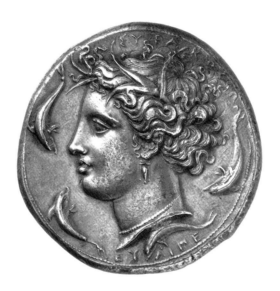

From about 1000 BCE, on most continents the first kingdoms gave way to vast cultural and political groups. The Assyrian and then Persian empires dominated the Near East, while Greek cities became established around the Mediterranean basin. The Nok and Olmec cultures spread across West Africa and Mesoamerica respectively. The evolution, encounters and clashes of these empires stimulated artistic and philosophical fusions whose influences are still felt today. After setting out from the Greek kingdom of Macedonia in 334 BCE, Alexander the Great forged an unprecedented political union between Europe and Asia that led to the formation of immense empires. As Rome, in its heyday, expanded its domination over the whole of the Mediterranean region, the Han empire was expanding enormously in China. The collapse of these empires led to a regeneration of artistic forms that would be used by universal religions to communicate their message.

BETWEEN EAST AND WEST

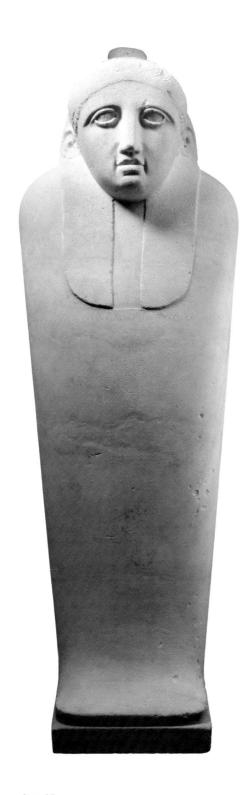

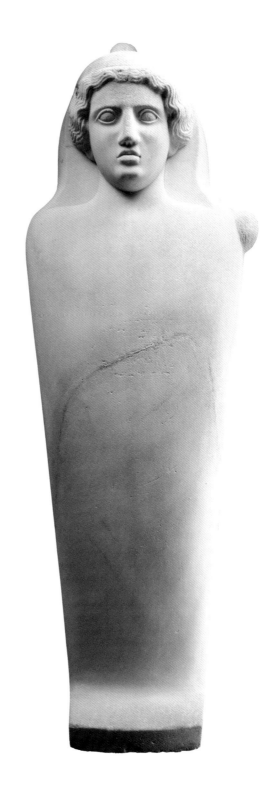

Page 27
**DECADRACHM WITH
AN IMAGE OF THE
NYMPH ARETHUSA**
Workshop of Euainetos
Italy, Sicily, Syracuse
412–393 BCE
Silver
LOUVRE ABU DHABI

**SARCOPHAGUS LID
IN EGYPTIAN STYLE**
Lebanon
c. 450 BCE
H. 220 cm; marble
LOUVRE ABU DHABI

**SARCHOPHAGUS LID
IN GREEK STYLE**
Lebanon
450–400 BCE
H. 232 cm; marble
LOUVRE ABU DHABI

**SPHINX, MYTHOLOGICAL
CREATURE**
Greece or Italy
600–500 BCE

H. 57 cm; limestone
LOUVRE ABU DHABI

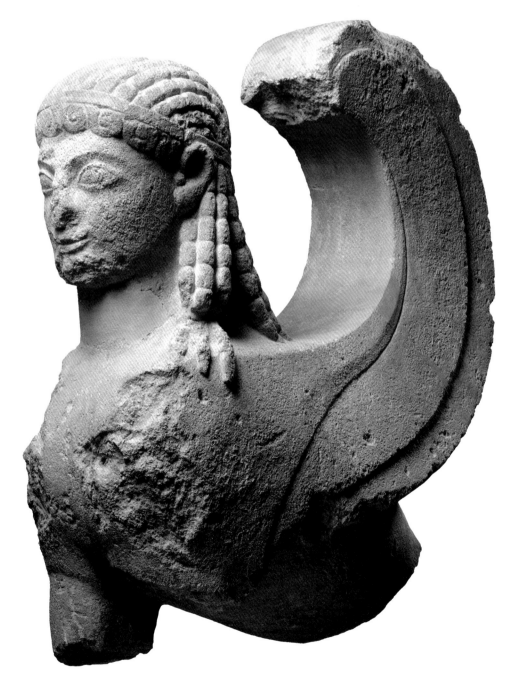

THE WINGED DRAGON, A MYTHICAL WORK

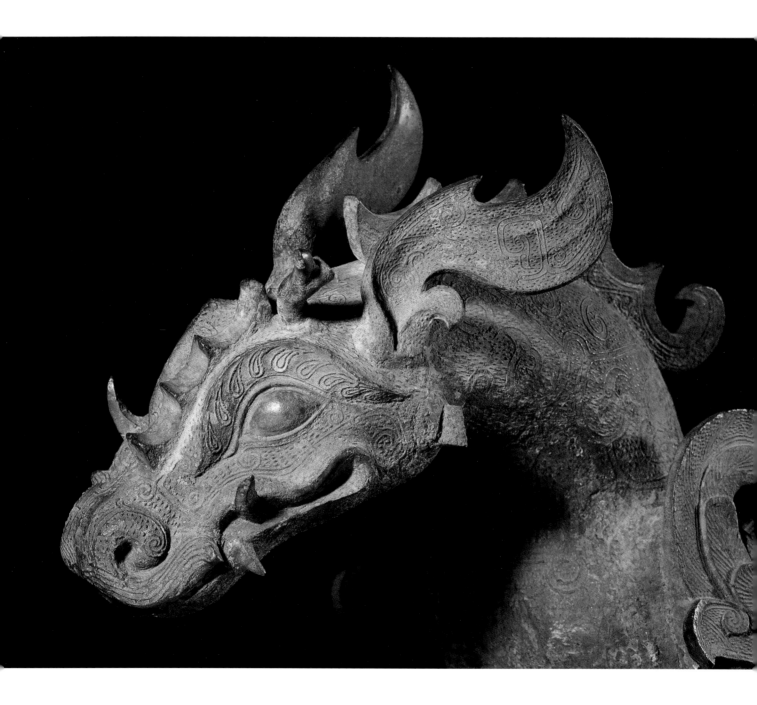

Very few works are comparable
with this one in terms
of dynamism, monumentality
and aesthetic quality.

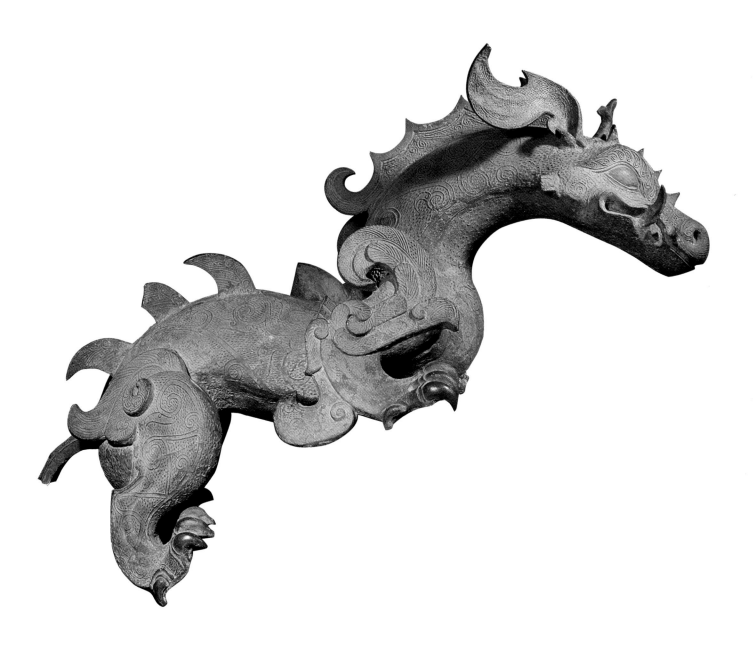

WINGED DRAGON
Northern China
450–250 BCE
H. 48.5, W. 67 cm; bronze

BANQUETS OF GODS AND BANQUETS OF MEN

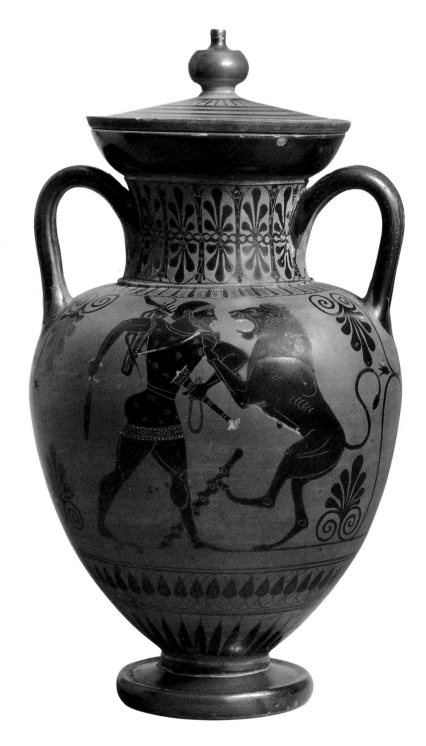

**AMPHORA SHOWING HERACLES
BATTLING THE NEMEAN LION**
Attributed to Antimenes (potter-painter in Athens)
Greece
c. 520 BCE
H. 38.2 cm; painted terracotta
LOUVRE ABU DHABI

The two vases, one Greek
and the other Chinese,
reflect the developing practice
in both civilisations
of the ritual customs
of the aristocratic banquet.

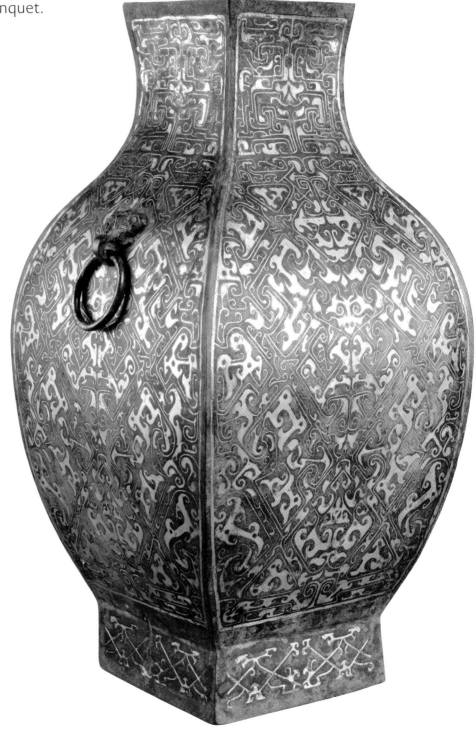

**CEREMONIAL VASE WITH
INTERLACING MOTIFS**
China
475–221 BCE
H. 48.5 cm; bronze, silver
LOUVRE ABU DHABI

ROMAN PORTRAITS

The proud gilded Roman head, with a beard
in the style of the Greek philosophers,
probably to give his image a greater
sense of profundity, seems to be contemplating
his tragic fate with irony.

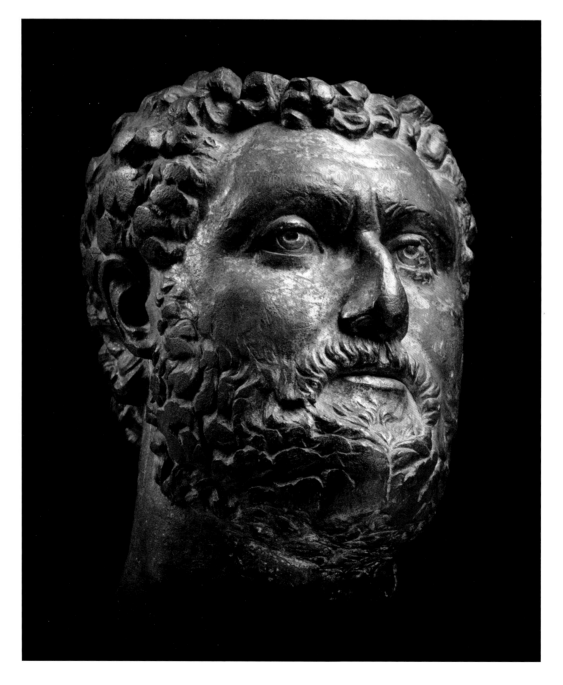

**HEAD OF A ROMAN EMPEROR,
FRAGMENT OF A MONUMENTAL STATUE**
Italy, Rome
c. 200 CE

H. 44, W. 34 cm; gilded bronze
LOUVRE ABU DHABI

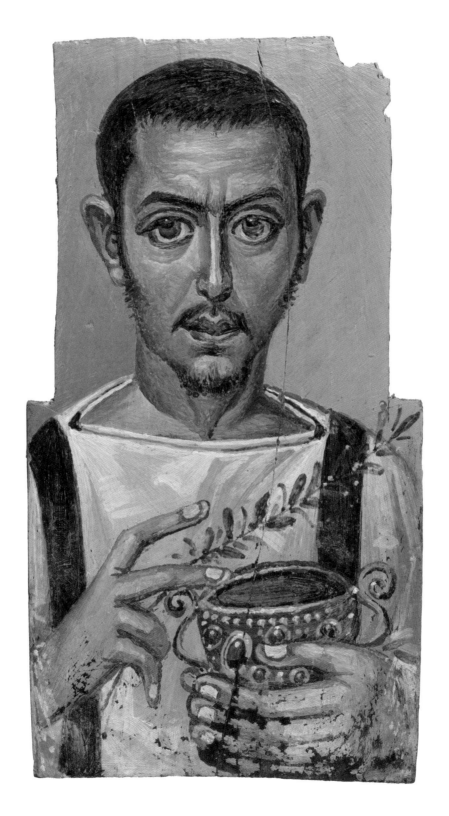

FUNERARY PORTRAIT OF A MAN WITH A CUP
Egypt, Antinopolis (?)
225–50 CE

H. 23, W. 12.7 cm; wax paint on wood
LOUVRE ABU DHABI

DIALOGUE BETWEEN ROME AND INDIA

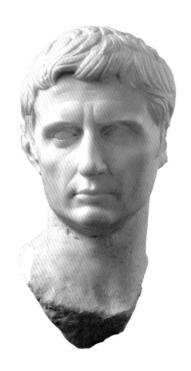

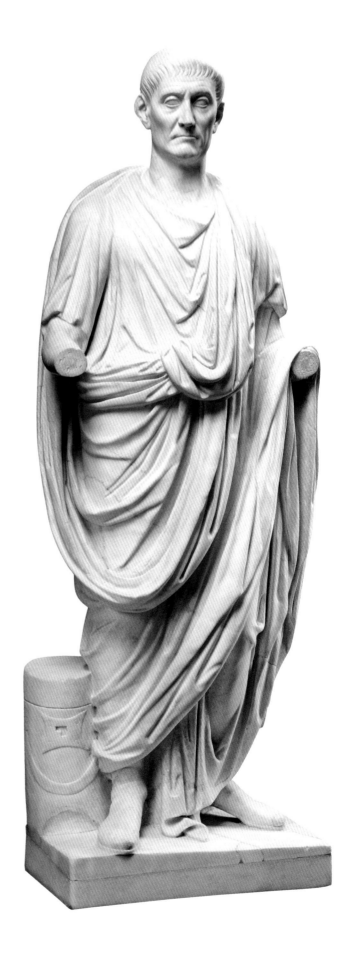

**AUGUSTUS, THE FIRST
ROMAN EMPEROR**
Italy, Rome (?)
27 BCE–100 CE
H. 52 cm; marble
LOUVRE ABU DHABI

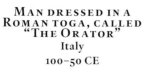

**MAN DRESSED IN A
ROMAN TOGA, CALLED
"THE ORATOR"**
Italy
100–50 CE
H. 169 cm; marble
LOUVRE ABU DHABI

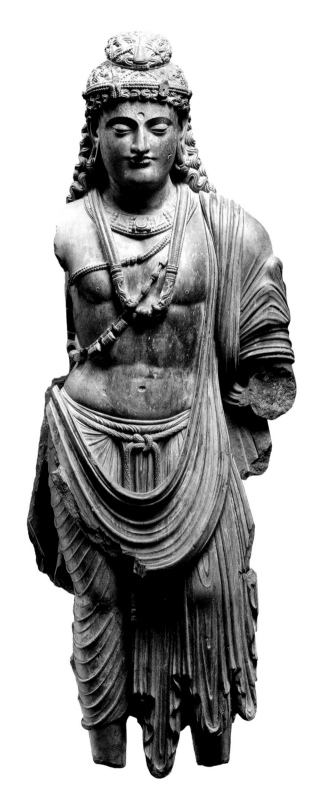

BODHISATTVA
Pakistan, Gandhara
100–300 CE

H. 136 cm; schist
LOUVRE ABU DHABI

THE END OF THE GREAT EMPIRES

BROOCH IN THE FORM OF AN EAGLE
Italian peninsula, San Marino, Domagnano
450–500 CE

H. 12.1, W. 6.4 cm; gold, garnet
LOUVRE ABU DHABI

UNIVERSAL
RELIGIONS

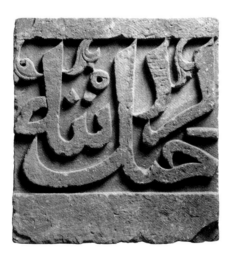

Beginning around 2000 years ago, the spread of universal religions succeeded in reaching most of the civilised areas of Europe, Asia and Africa in just a few centuries. By addressing their message to all humanity without distinction, Buddhism, Christianity and Islam transcended local cultural characteristics and deeply transformed communities that had thrived during Antiquity. These religions shared with Judaism the notion of monotheism, but diverged on issues such as the representation of the divine. Their expansion was sometimes conflictual and brought them into contact with other beliefs, such as Hinduism in Asia, Confucianism and Taoism in China, Shintoism in Japan, and animism in Africa. Religion had by this time become a factor that united communities and exerted an influence on intellectual and artistic pursuits across whole continents.

SYMBOLS OF THE DIVINE

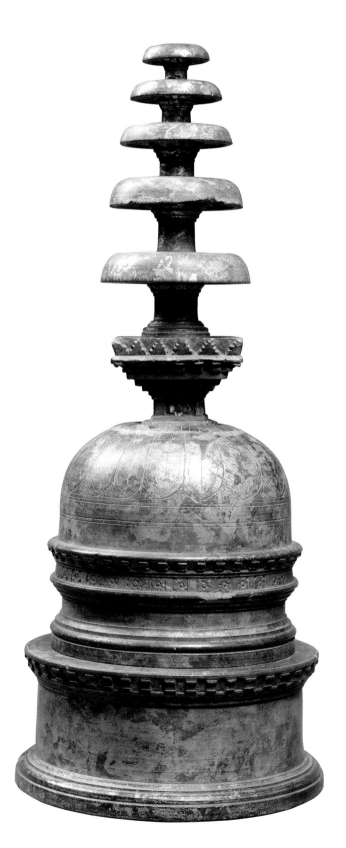

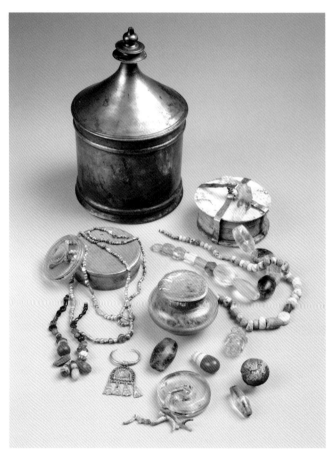

**RELIQUARY IN THE
FORM OF A STUPA,
AND ITS CONTENTS**
Pakistan, Gandhara,
Swat Valley (?)
20–30 CE

H. 78 cm; gilded schist, gold,
crystal, coral, glass
LOUVRE ABU DHABI

Page 39
**ARCHITECTURAL
FRIEZE CARVED WITH
QURANIC VERSES**
Northern India, Rajasthan (?)
c. 1200

Total length: 888 cm; sandstone
LOUVRE ABU DHABI

**STUPA REVETMENT
PLAQUE**
India, Amaravati region
100–300 CE

H. 129.5 cm; stone
LOUVRE ABU DHABI

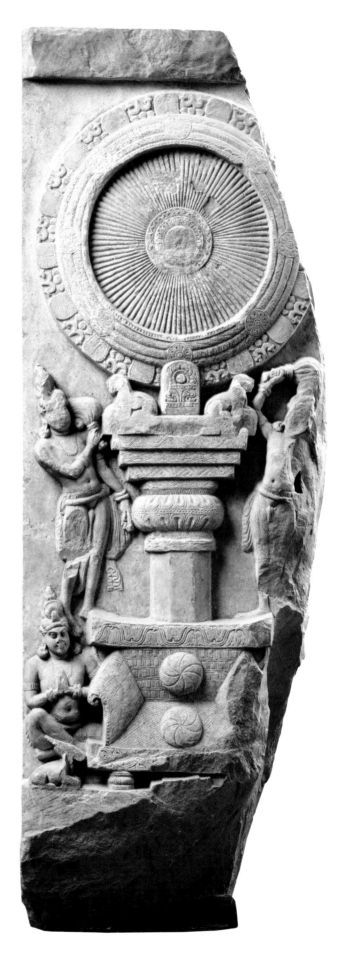

FACES OF BUDDHISM

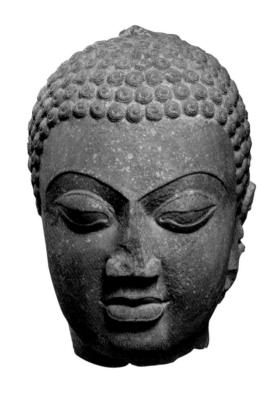

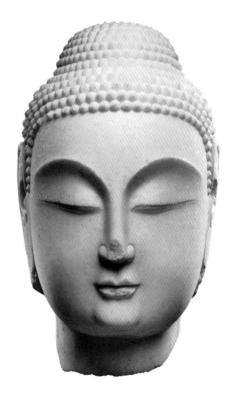

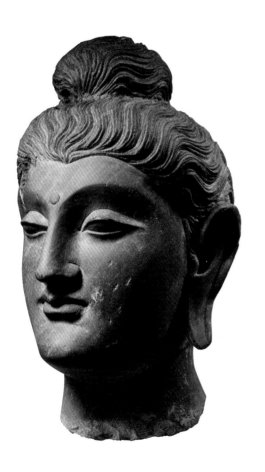

BUDDHA HEAD
Northern India, Mathura region
400–500 CE

H. 38.6 cm; red sandstone
LOUVRE ABU DHABI

BUDDHA HEAD
Northern China
530–80 CE

H. 51 cm; white marble
LOUVRE ABU DHABI

BUDDHA HEAD
Pakistan, Gandhara
100–300 CE

H. 30 cm; schist
LOUVRE ABU DHABI

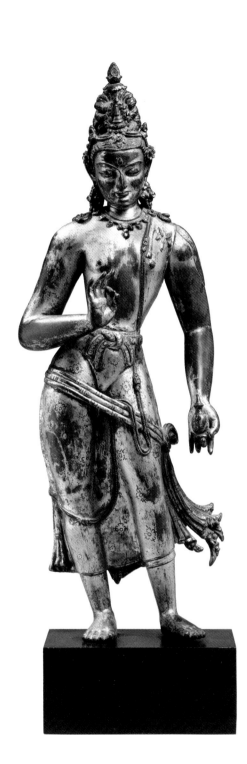

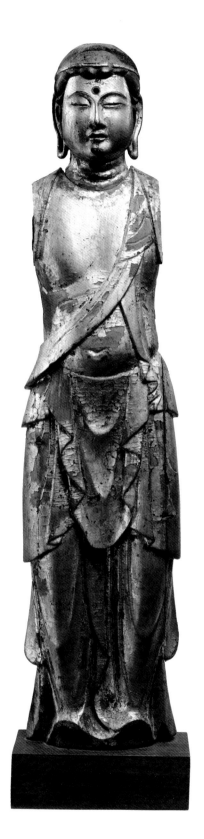

**MAITREYA, A BUDDHA
IN A TIME YET TO COME**
Nepal
1100–1200

H. 52 cm; copper gilt,
semiprecious stones
LOUVRE ABU DHABI

**SHÔ-KANNON,
BODHISATTVA
OF COMPASSION**
Japan
1100–1300

H. 78 cm; wood, black lacquer, gold
LOUVRE ABU DHABI

INCARNATIONS OF THE SACRED

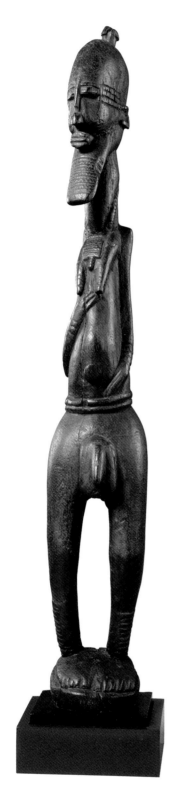

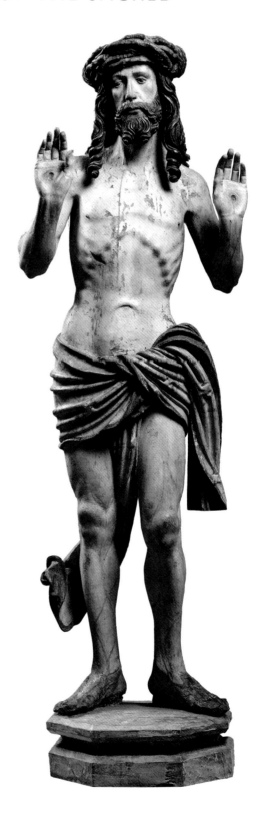

ANCESTOR FIGURE
Mali
1200–1300
H. 95.5 cm; wood
LOUVRE ABU DHABI

CHRIST SHOWING
HIS WOUNDS
Germany (Bavaria) or Austria
1515–20
H. 183 cm; painted wood
LOUVRE ABU DHABI

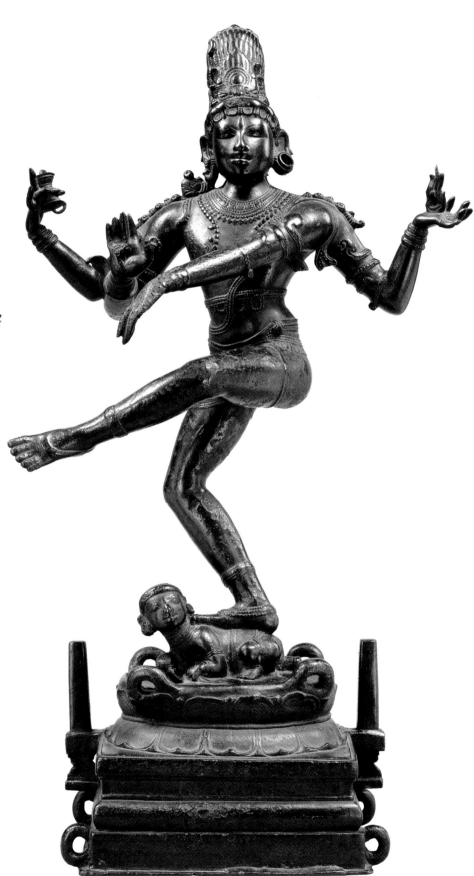

**DANCING SHIVA,
HINDU DIVINITY**
India, Tamil Nadu
950–1000
H. 76.2 cm; bronze
LOUVRE ABU DHABI

SACRED TEXTS

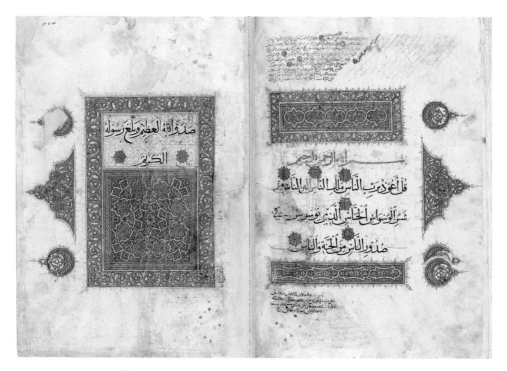

JUZ' AMMA, 30TH SECTION OF THE HOLY QURAN
Syria, Damascus (?)
1250–1300

H. 47, W. 62 cm; ink, colour and gold on paper, leather binding
LOUVRE ABU DHABI

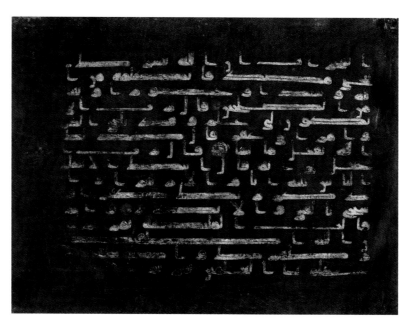

PAGE OF THE "BLUE QURAN"
North Africa
c. 900

H. 29.8, W. 34.6 cm; gold on dyed parchment
LOUVRE ABU DHABI

ARCHITECTURAL FRIEZE CARVED WITH QURANIC VERSES
Northern India, Rajasthan (?)
c. 1200
Total length: 888 cm; sandstone
LOUVRE ABU DHABI

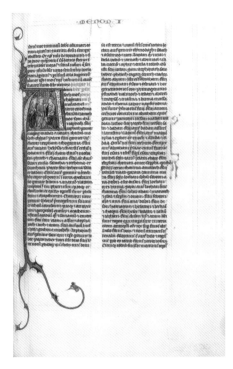

GOTHIC BIBLE IN TWO VOLUMES
France, Paris
1250–80
H. 38.2, W. 28.5 cm; parchment
LOUVRE ABU DHABI

PENTATEUCH AND ITS BINDING
Yemen, Sana'a
1498
H. 30, W. 17 cm; ink on paper
LOUVRE ABU DHABI

SACRED TEXTS

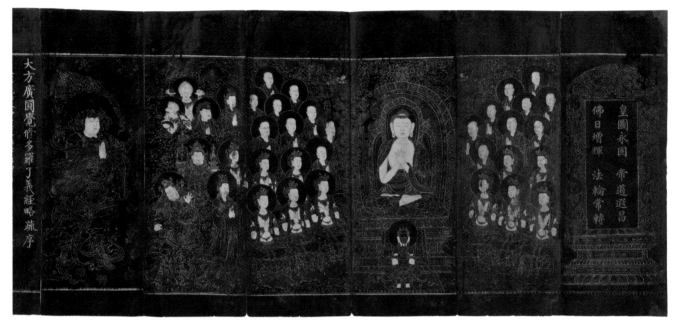

THE SUTRA OF PERFECT ENLIGHTENMENT
China
1350–1400
H. 19, W. 41.2 cm; gold ink on paper
LOUVRE ABU DHABI

THE SUTRA OF THE PERFECTION OF WISDOM
Eastern India
1191
H. 11, W. 32 cm; ink and gouache on palm leaves
LOUVRE ABU DHABI

ASIAN
TRADE ROUTES

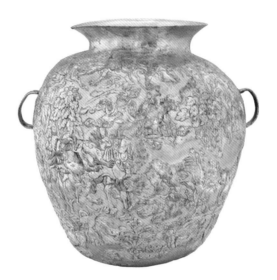

The expansion of the universal religions occurred in parallel with the establishment of vast networks of exchange between continents. In Asia in the 7th century, China became the main actor in these exchanges and a major centre of innovation. The invention of porcelain, gunpowder, paper and printing characters were to change the world. China passed most of its inventions to the Arab-Muslim world along the land and sea routes used in the silk trade. The Islamic civilisation lay at the heart of this thriving trade network that linked Asia, Europe and Africa. From the 8th to 10th centuries, Baghdad experienced a golden age in the arts and sciences. The caravan routes taken by merchants crossed the paths followed by pilgrims, encouraging the spread of new modes of thought. These exchanges boosted the circulation of exotic materials and luxury items like silk, ceramics, jewellery, incense and ivory.

THE INFLUENCE OF IMPERIAL CHINA

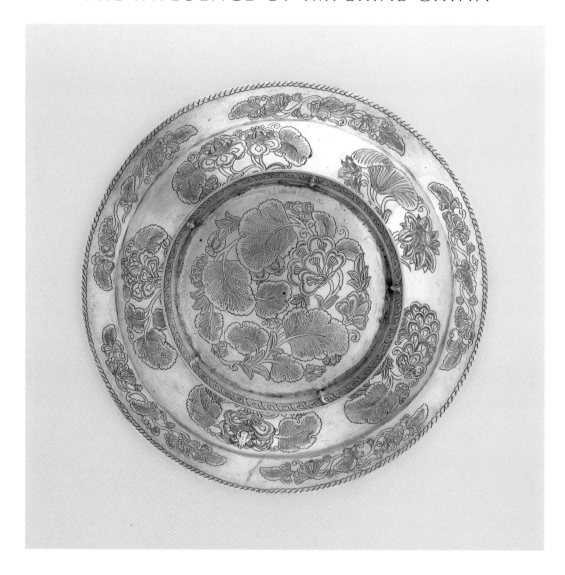

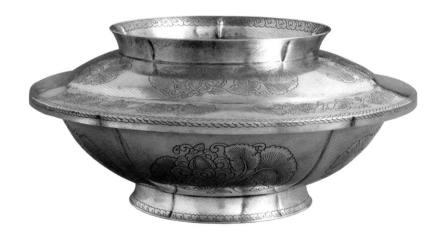

Page 49
**JAR DECORATED WITH
HUNTING SCENES**
Central Asia or Tibet
400–600

H. 38.5 cm; silver gilt
LOUVRE ABU DHABI

**DISH DECORATED
WITH PLANT MOTIFS**
China
c. 800

Diam. 24.5 cm; gold, silver
LOUVRE ABU DHABI

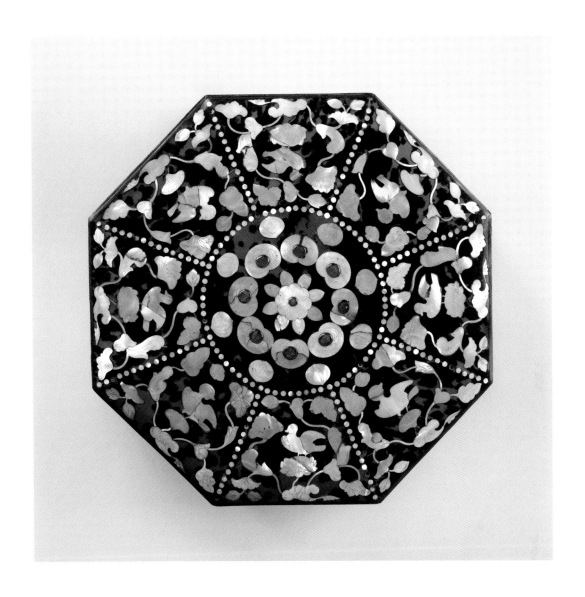

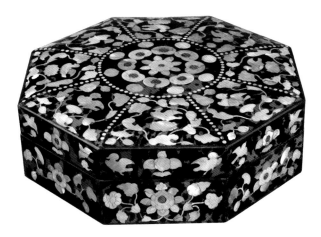

OCTAGONAL BOX
China
700–800

Diam. 38.5 cm; wood, tortoiseshell, mother-of-pearl, amber
LOUVRE ABU DHABI

POTTERY IN THE ISLAMIC WORLD

**BOWL WITH INSCRIPTION
IN KUFIC STYLE**
Iraq
800–900

Diam. 19 cm; earthenware
with painted overglaze
LOUVRE ABU DHABI

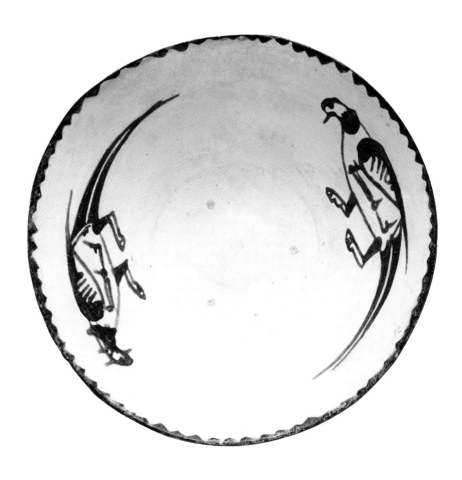

**BOWL DECORATED WITH
BIRDS ENCLOSING THE
INSCRIPTION "BLESSING"**
Central Asia
900–1000

Diam. 25 cm; ceramic, with
underglaze slip decoration
LOUVRE ABU DHABI

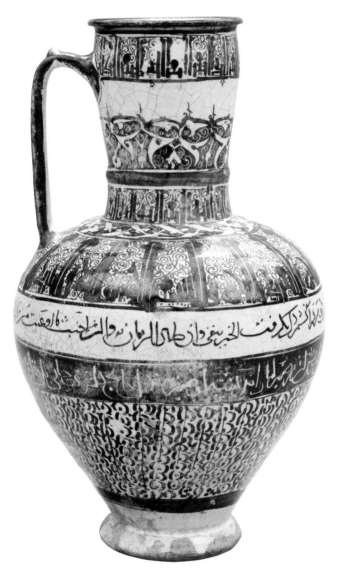

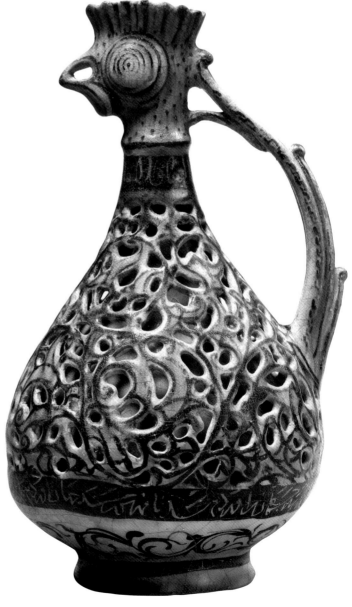

**JUG WITH POETIC
INSCRIPTIONS**
Iran, Kashan
c. 1200
H. 25.3 cm; ceramic with lustre painting
LOUVRE ABU DHABI

ROOSTER-HEADED EWER
Iran
1100–1300
H. 29 cm; ceramic with openwork
decoration and underglaze painting
LOUVRE ABU DHABI

THE ARTS OF METAL

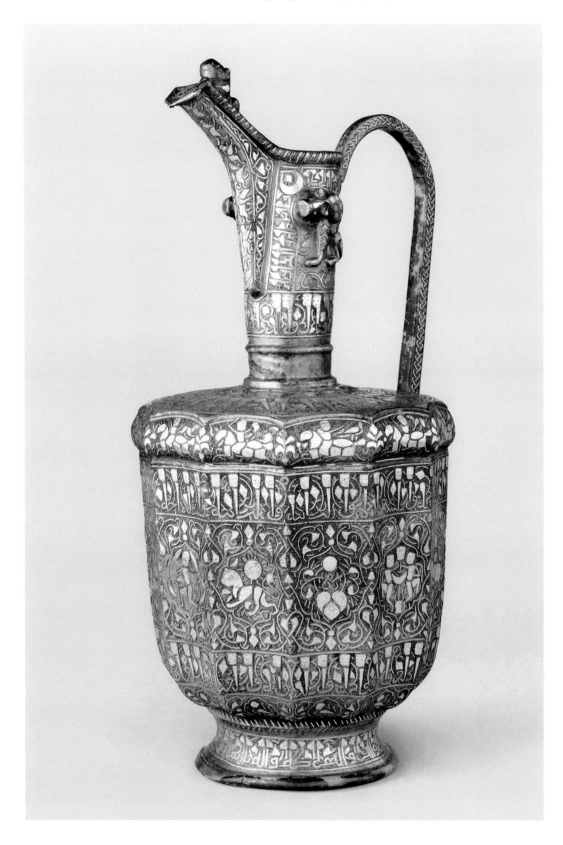

EWER DECORATED WITH THE SIGNS OF THE ZODIAC
Afghanistan, Herat
c. 1220

H. 38 cm; copper alloy, silver
LOUVRE ABU DHABI

"May God strengthen his assistants, and increase his power /
and the nobility of his rank. May his good fortune never cease
to manifest itself and his stars to dazzle as long as he shall shine
forth and [...] In the hope of goodness."

Expression of good wishes engraved on the platter

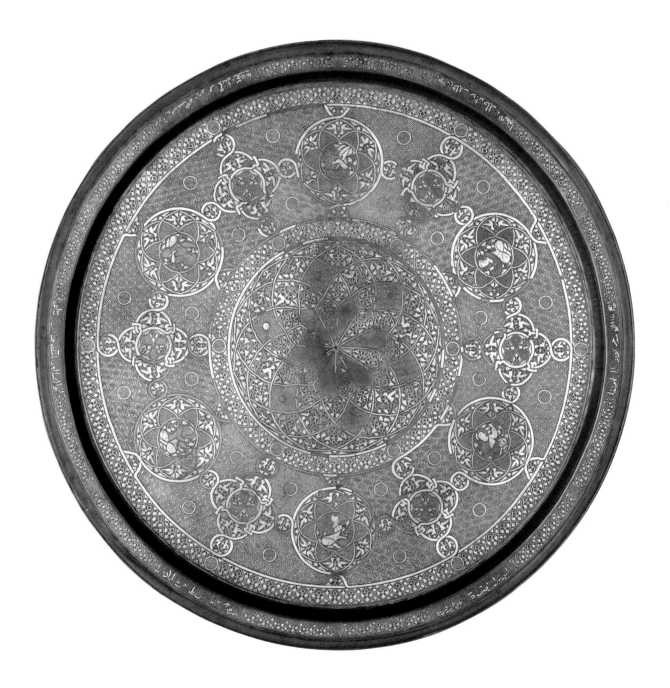

PLATTER WITH DRINKERS AND MUSICIANS
Al-Jazira (northern Syria and north-west Iraq)
1250–1325

Diam. 53.2 cm; copper alloy, silver, gold
LOUVRE ABU DHABI

A LUXURY CARPET

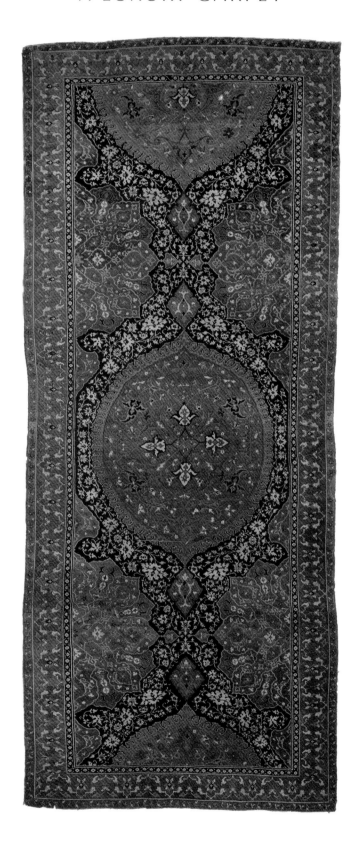

MEDALLION CARPET
Turkey, Ushak
c. 1480
L. 653.5, W. 273 cm; wool
LOUVRE ABU DHABI

FROM THE MEDITERRANEAN TO THE ATLANTIC

The Mediterranean basin was the culminating point of the commercial and cultural routes across Asia and Africa. From the 11th century, exchanges increased between the Byzantine empire, the Islamic world and Christian Europe, in spite of their rivalries and conflicts. While the cities of Venice and Genoa took an active part in these exchanges, the Iberian Peninsula, divided between Islam and Christianity, became a site of rich cultural diversity. In Europe, competition between Christian kingdoms and flourishing trade contributed to economic and scientific development. At the end of the 15th century, Portuguese navigators explored the coastline of Africa and opened new trade routes to the Indian Ocean. The crossing of the Atlantic and discovery of the American continent created contact between Europe and the Amerindian civilisations, which had until then remained isolated.

THE IVORY TRADE

DIPTYCH WITH SCENES
FROM THE LIFE OF CHRIST
France or Germany
1350–75
H. 21, W. 24 cm; ivory
LOUVRE ABU DHABI

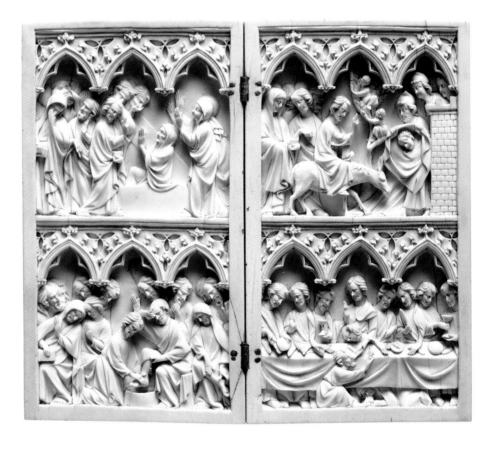

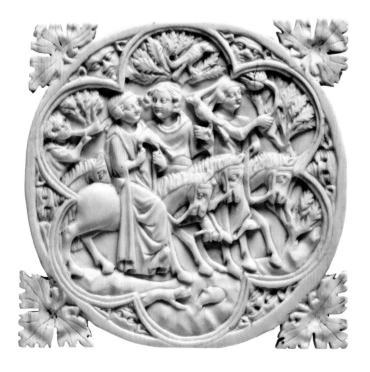

MIRROR CASE: HUNTING
WITH A FALCON
France, Paris
1330–50
H. 10, W. 10 cm; ivory
LOUVRE ABU DHABI

VIRGIN AND CHILD
France, Paris
1300–1400
H. 23 cm; ivory
LOUVRE ABU DHABI

Page 57
"DE MATERIA MEDICA",
A PHARMACOPEIA
OF PLANTS
Pedanius Dioscorides (40–90 CE)
Iraq, Baghdad
Arabic edition, 1200–1300
H. 25, W. 16.8 cm;
ink and paint on paper
LOUVRE ABU DHABI

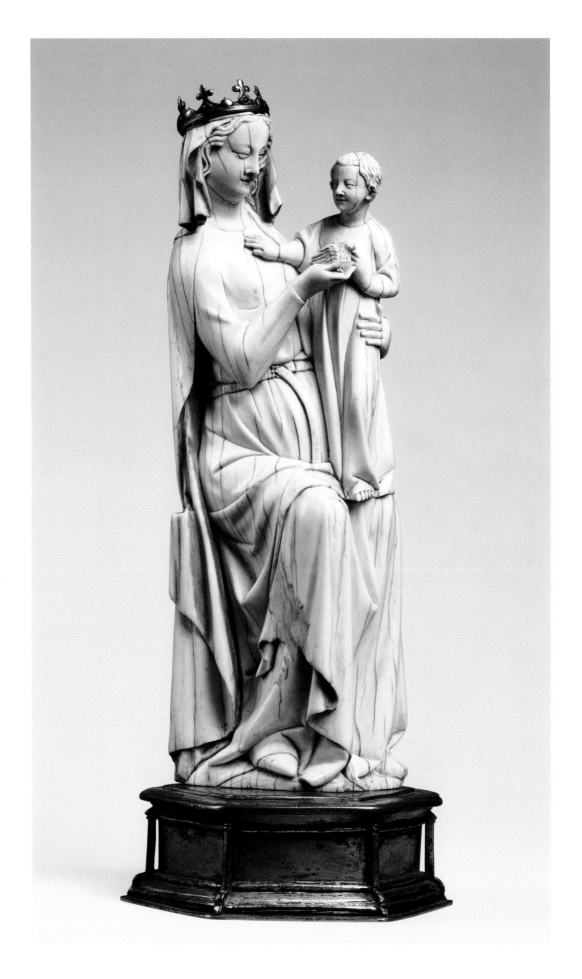

THE MARI-CHA LION

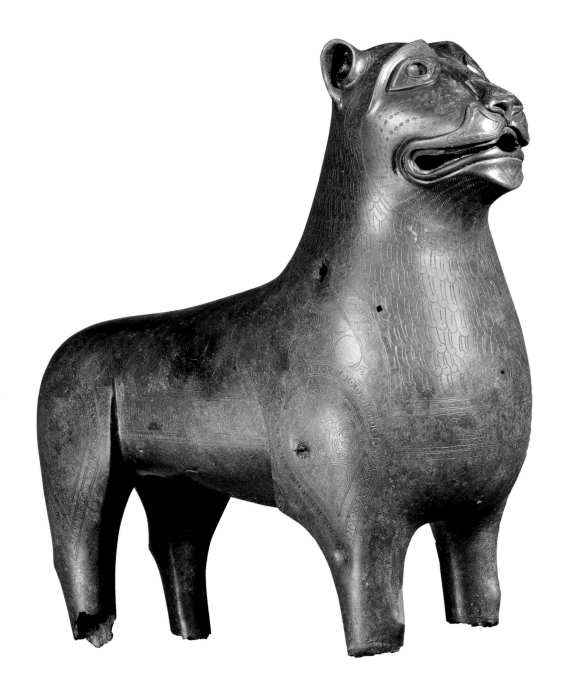

"MARI-CHA" LION
Spain or southern Italy
1000–1200

H. 73 cm; bronze
LOUVRE ABU DHABI

THE SYMBOLISM OF WATER

"Of the greatest artists in the world, he is the second.
The world applauds him who skilfully sculpted this famous
basin, whose talent is so greatly praised
and blessed. His name is Bonifilius."

Inscription on the rim of the basin

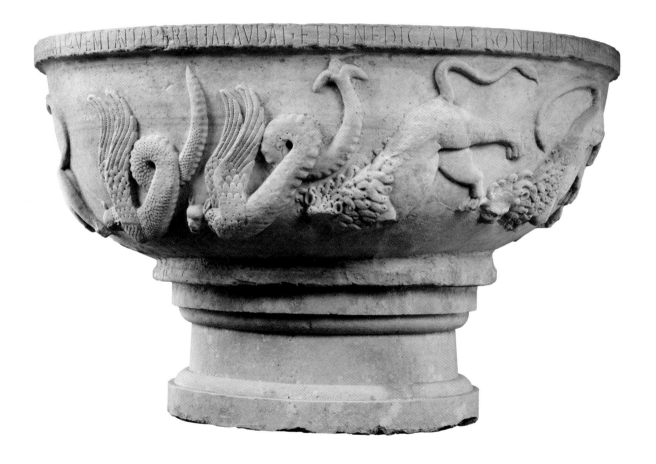

**BASIN INSCRIBED
WITH THE NAME OF BONIFILIUS**
Northern Italy
c. 1300
Diam. 137 cm; marble
LOUVRE ABU DHABI

VIRGIN AND CHILD

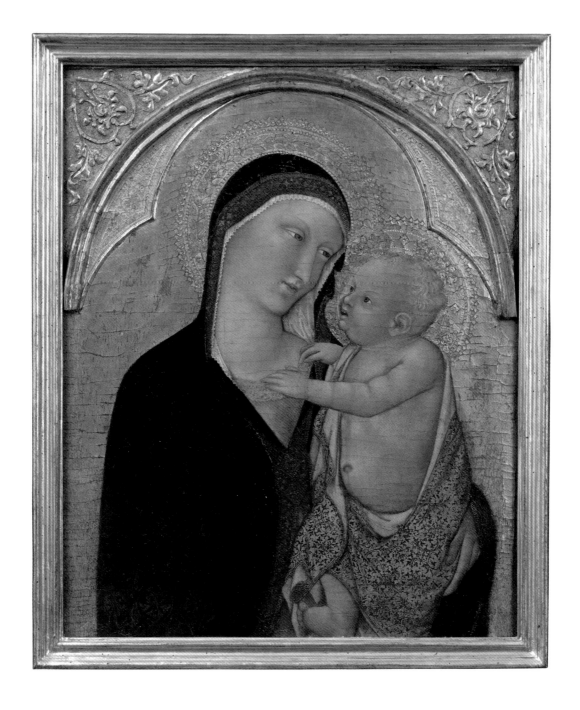

VIRGIN AND CHILD
Francesco Traini (active 1321–45)
Italy
c. 1325
H. 67.5, W. 56 cm; tempera on wood panel
LOUVRE ABU DHABI

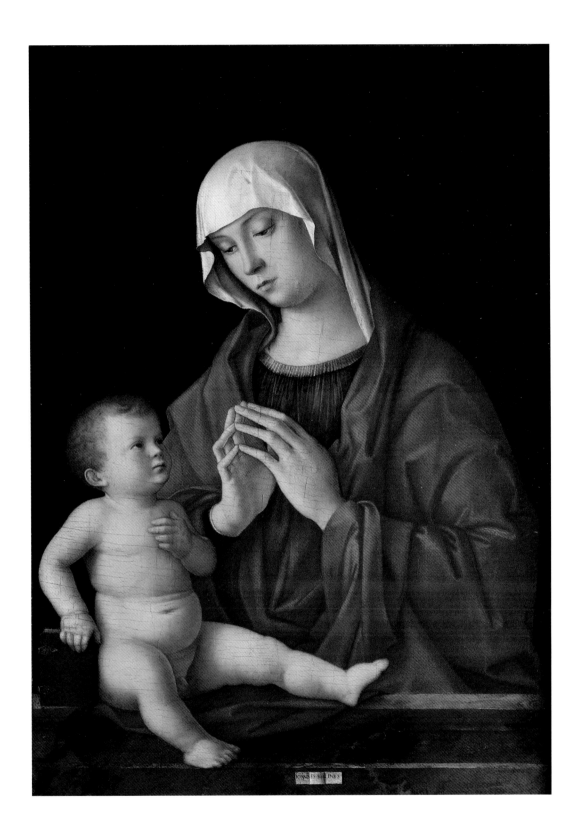

VIRGIN AND CHILD
Giovanni Bellini (1430–1516)
Italy, Venice
1480–85

H. 109, W. 85 cm; oil on wood panel
LOUVRE ABU DHABI

SCIENTISTS, PHILOSOPHERS AND POETS

**CHALDEAN HISTORY,
CHRONICLE OF THE
KINGS OF BABYLON**
Berosus (active c. 300 BCE)
France, Paris
Latin edition of 1505

H. 25.4, W. 18.7 cm; ink and gouache
on parchment, gold highlights
LOUVRE ABU DHABI

**"DE MATERIA MEDICA",
A PHARMACOPEIA
OF PLANTS**
Pedanius Dioscorides (40–90 CE)
Iraq, Baghdad
Arabic edition, 1200–1300

H. 25, W. 16.8 cm;
ink and paint on paper
LOUVRE ABU DHABI

COSMOGRAPHIES

Around 1500, for the first time since the beginning of humanity, man was able to travel around the globe. Great navigators, such as Ibn Majid, Zheng He and Christopher Columbus, established direct contact between lands that hitherto had remained remote or unknown to one another. Civilisations that had once traded on the grounds of geographical proximity gradually engaged in a system of exchanges on a global scale. The world witnessed an early form of globalisation. Awareness of the magnitude of the world prompted questions about the meaning of the universe. Instruments used in navigation and cosmography developed rapidly. The first travelogues were published, recounting journeys to distant lands, while maps and globes charted the contours of this new world. The exotic materials and strangely-shaped works of art that filled "cabinets of curiosities" in Europe illustrated the fascination for distant and mysterious lands.

MEASURING THE WORLD

"This astrolabe was donated as a religious endowment by
al-Mu'azzam Muhammad [?], head of the cavalry, to the Grand Mosque
of Algiers, protected by God. May nobody remove it from
the mosque, in the charge of those responsible for the regulation
of the times of prayer. Dated at the end of [the month of]
Rajab in the year 1158 [August 1745]."

Inscription on the astrolabe

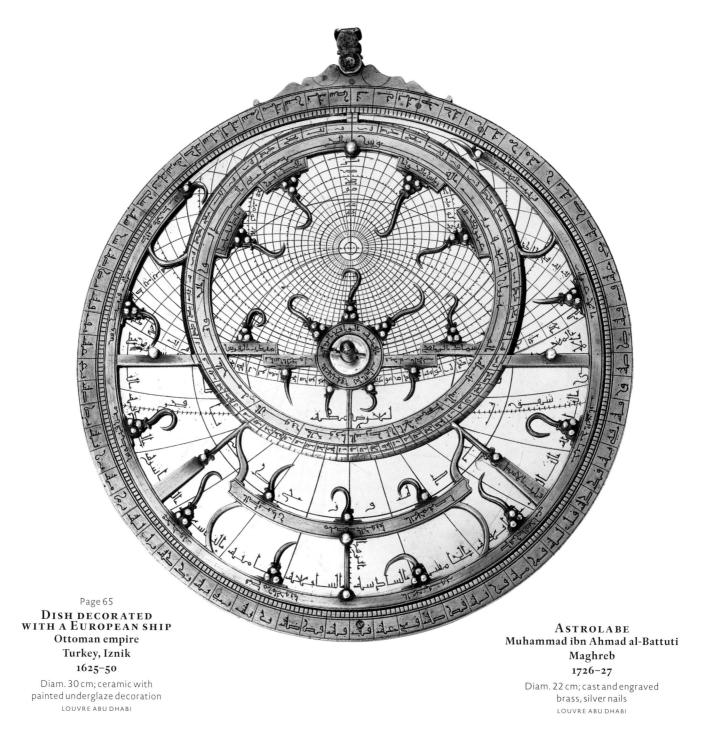

Page 65
**DISH DECORATED
WITH A EUROPEAN SHIP**
Ottoman empire
Turkey, Iznik
1625–50

Diam. 30 cm; ceramic with
painted underglaze decoration
LOUVRE ABU DHABI

ASTROLABE
Muhammad ibn Ahmad al-Battuti
Maghreb
1726–27

Diam. 22 cm; cast and engraved
brass, silver nails
LOUVRE ABU DHABI

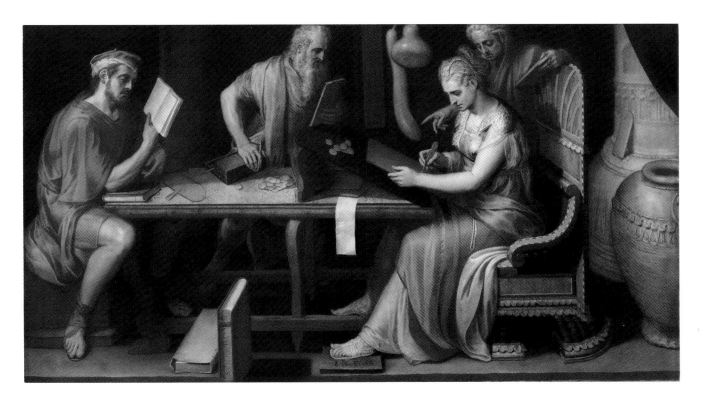

ALLEGORY OF ARITHMETIC
Frans Floris (1517–1570)
Belgium, Antwerp
1557
H. 146, W. 250 cm; oil on canvas
LOUVRE ABU DHABI

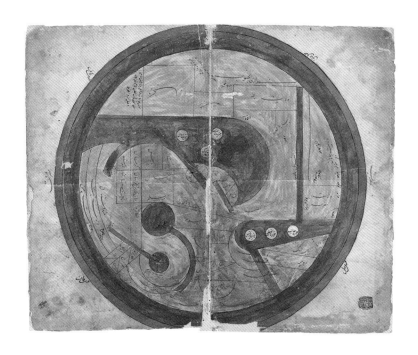

MAP OF THE WORLD
Iraq
1400–1500
H. 27.5, W. 33 cm; ink and gold on paper
LOUVRE ABU DHABI

JAPAN AND THE WORLD

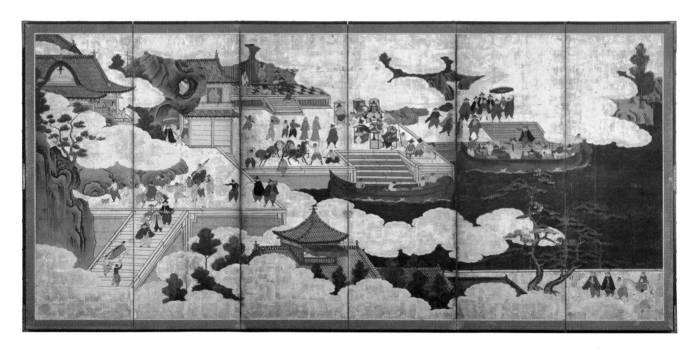

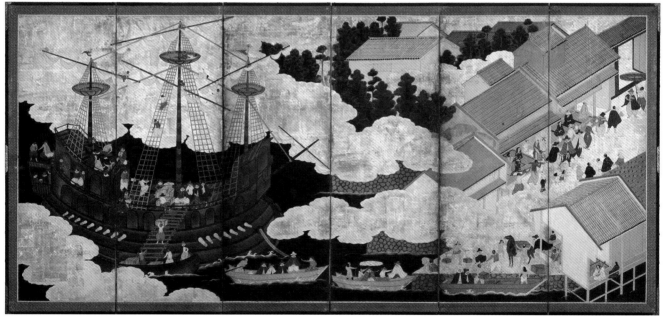

**PAIR OF FOLDING SCREENS SHOWING THE ARRIVAL
OF PORTUGUESE MERCHANTS IN JAPAN**
Japan
c. 1625

H. 171, W. 376.8 cm; ink, colour and gold on paper
LOUVRE ABU DHABI

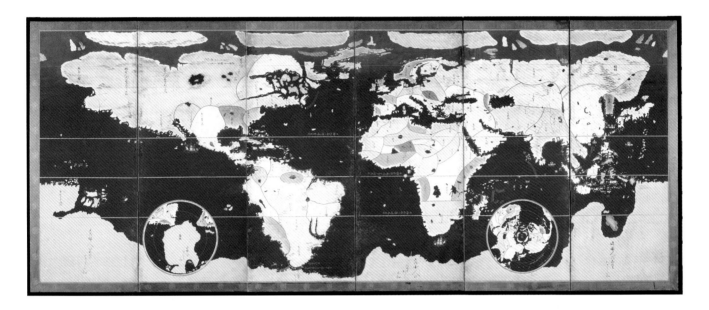

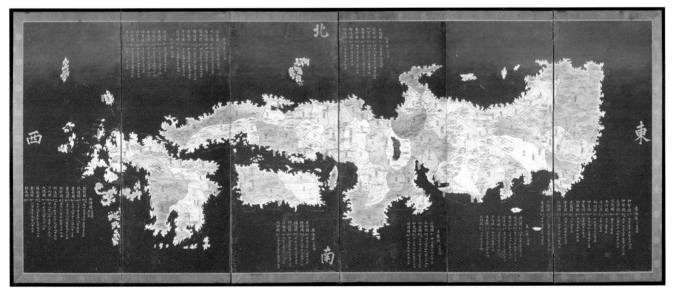

**PAIR OF FOLDING SCREENS WITH MAPS
OF JAPAN AND THE WORLD**
Japan
c. 1690

H. 104.5, W. 267 cm; ink, colours and gold on paper
LOUVRE ABU DHABI

AN OBJECT OF CURIOSITY

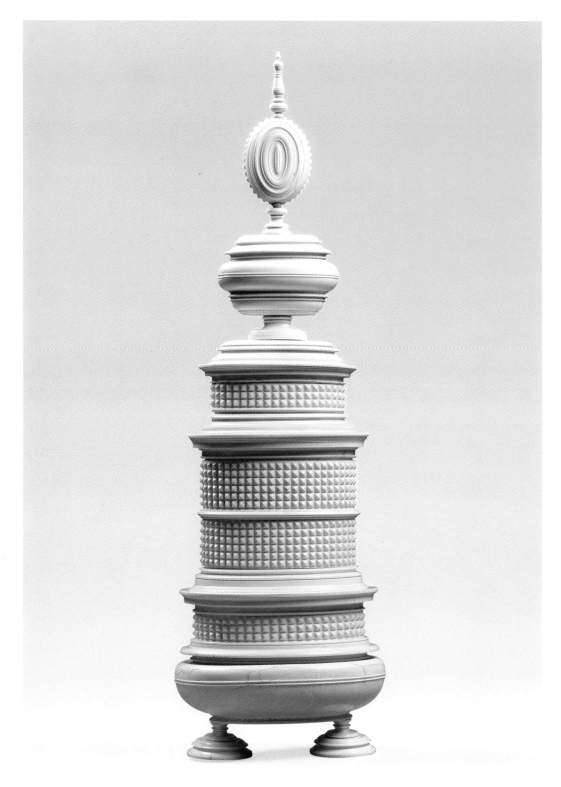

CANISTER TOWER
Achille Hermansreyt (?)
Central Europe, Holy Roman Empire
1657
H. 64.2 cm; ivory
LOUVRE ABU DHABI

THE WORLD
IN PERSPECTIVE

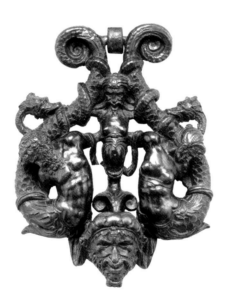

Pioneering voyages broadened horizons and offered a new perspective of the world. Discoveries in the fields of mathematics and optics transmitted from the Arab world to Europe in the 15th century had important consequences for art. Forming the foundation of the geometric and abstract approach to representation in Islamic art, they also enabled European artists to depict depth and three-dimensionality in an image. The flourishing intellectual and artistic activity of the time was called the Renaissance by Europeans rediscovering their Antiquity. For artists and architects it provided an aesthetic model that profoundly renewed the representation of the human body and landscapes. In China, too, artists found inspiration in the models of the past to strengthen the cultural and political legitimacy of their monarchs. Meanwhile, the Arab-Islamic world developed an international style that placed emphasis on the use of geometric and floral forms.

ISLAMIC GEOMETRY

TILE WITH VOLUTE DECORATION ON A RED GROUND
Turkey, Iznik
1575–80

H. 15.3, W. 24.4 cm; ceramic with painted underglaze decoration
LOUVRE ABU DHABI

Page 71
**DOOR KNOCKER WITH
MYTHOLOGICAL FIGURES**
Italy, Venice or Mantua
1500–50

H. 32.5 cm; bronze
LOUVRE ABU DHABI

**TILES WITH LOTUS
FLOWERS AND LEAVES
IN THE SAZ STYLE**
Turkey, Iznik
1575–80

H. 62.4, W. 62.4 cm; ceramic with
painted underglaze decoration
LOUVRE ABU DHABI

In the Islamic arts, geometry inspired a vision of the world founded on order, harmony, precision and measure.

OCTAGONAL FOUNTAIN AND ITS FLOORING
Syria, Damascus
1700-1800

L. 548, W. 509 cm; marble, limestone, slate
LOUVRE ABU DHABI

REALITY ENNOBLED

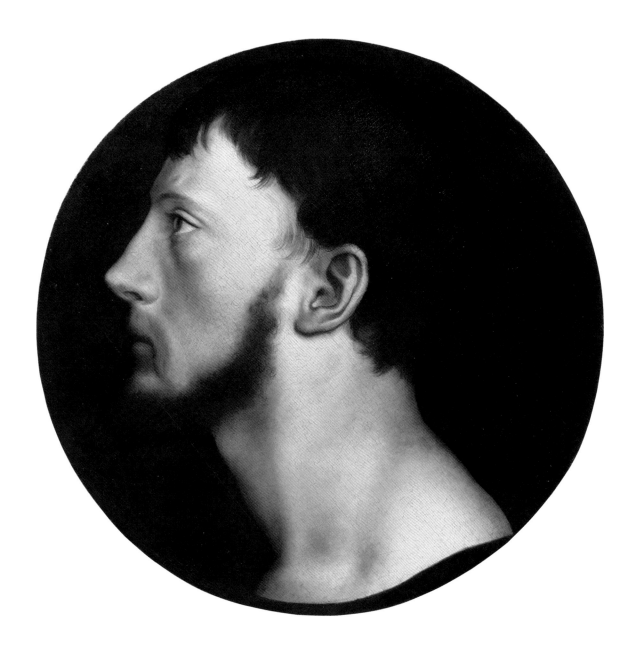

PORTRAIT OF SIR THOMAS WYATT THE YOUNGER
Hans Holbein the Younger (1497/98–1543)
United Kingdom
1540–42

Diam. 32 cm; oil on panel
LOUVRE ABU DHABI

ST PETER, CHRISTIAN MARTYR
Andrea della Robbia (1435–1525)
Italy, Florence
c. 1490

H. 59 cm; enamelled ceramic
LOUVRE ABU DHABI

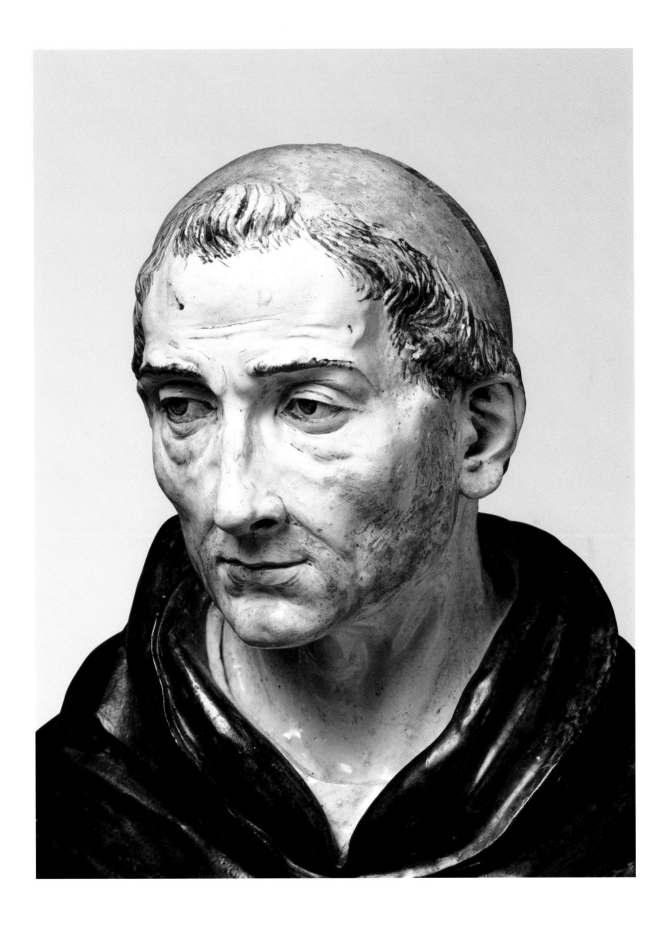

THE ART OF CERAMICS

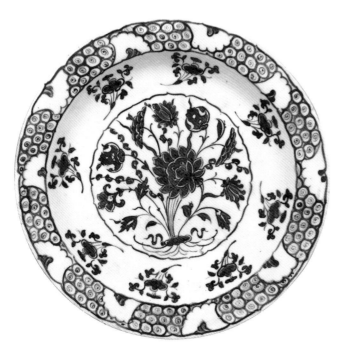

BLUE AND WHITE DISH WITH A LOTUS BOUQUET
Turkey, Iznik
1570–75
Diam. 30 cm; ceramic with a painted underglaze decoration
LOUVRE ABU DHABI

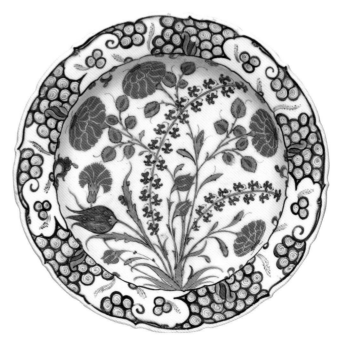

DISH WITH FOUR FLOWERS
Turkey, Iznik
c. 1575
Diam. 28.3 cm; ceramic with a painted underglaze decoration
LOUVRE ABU DHABI

**DISH WITH TRACERY
AND THE BUST OF A WOMAN**
Jacomo Da Pesaro (?–1546)
Italy, Venice
1534–43
Diam. 45.2 cm; painted faience
LOUVRE ABU DHABI

DISH WITH A TROPHY OF ARMS
Jacomo Da Pesaro (?–1546)
Italy, Venice
1530–43
Diam. 46.5 cm; painted faience
LOUVRE ABU DHABI

THE MAGNIFICENCE OF THE COURT

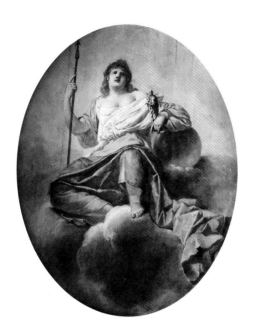

Encounters between different worlds led to unprecedented rivalry between rulers. This phenomenon took on a new dimension in the 17th century and occurred simultaneously throughout Europe, China, the Muslim empires, and the kingdoms of Africa. Sovereigns glorified themselves by displaying symbols of their power and commissioning majestic representations of their royal person and court. Equestrian portraits became a widespread form of representation. Monarchs competed to attract the best artists, commissioned new decorative settings, and invested enormous amounts in the construction of palaces and religious buildings of exceptional opulence. The magnificence of court life, the luxury of costumes and weaponry, and the splendour of art collections gave rulers a dazzling image that was designed to overshadow other kingdoms and states.

PORTRAITS OF PRINCES

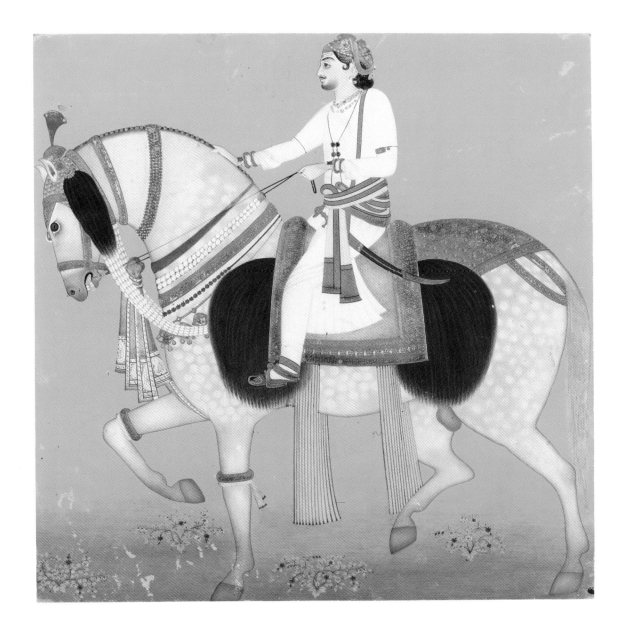

Page 77
**INTERIOR DECORATION
WITH AN ALLEGORY OF
NOBILITY (DETAIL)**
France, Paris
c. 1650

H. 314.4, W. 392.5 cm; wood,
painted decoration, gold
LOUVRE ABU DHABI

**EQUESTRIAN PORTRAIT
OF MAHARAO SHEODAN
SINGH OF ALWAR**
India
c. 1863

H. 21.5, W. 21.5 cm; gouache
with gold highlights on paper
LOUVRE ABU DHABI

**EQUESTRIAN PORTRAIT
OF PHILIP V,
KING OF SPAIN**
Lorenzo Vaccaro (1655–1706)
Italy
1702–05
H. 100 cm; bronze
LOUVRE ABU DHABI

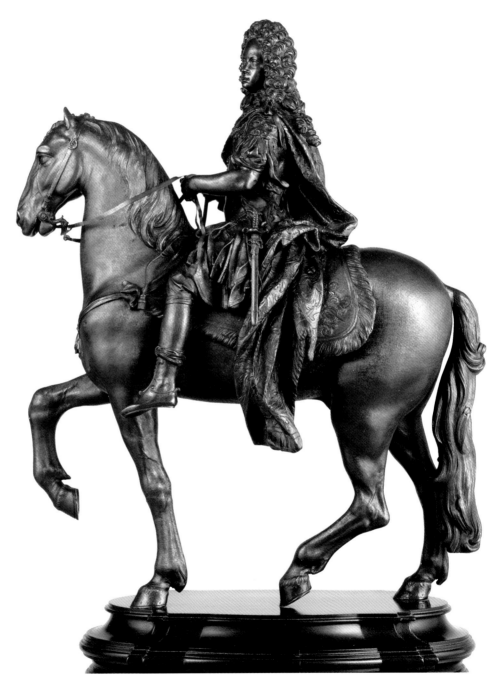

BAROQUE AND CLASSICAL ART IN EUROPE

THESEUS FINDING HIS FATHER'S SWORD
Laurent de La Hyre (1606–1656)
France, Paris
1639–41

H. 205.4, W. 162 cm; oil on canvas
LOUVRE ABU DHABI

STILL LIFE IN A PANTRY
Jérémie Plume
France
1628

H. 105.5, W. 200 cm; oil on canvas
LOUVRE ABU DHABI

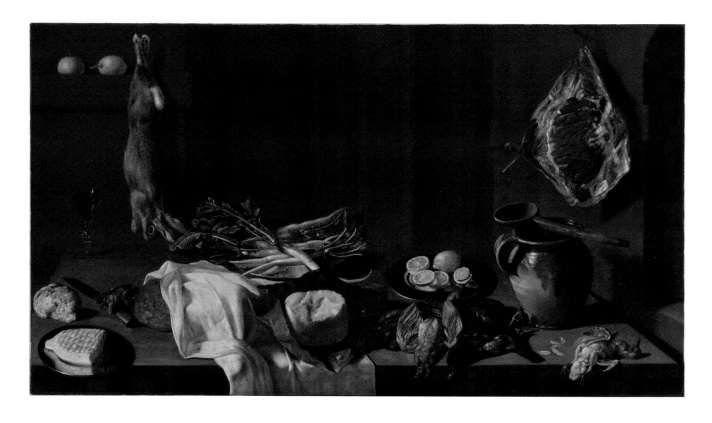

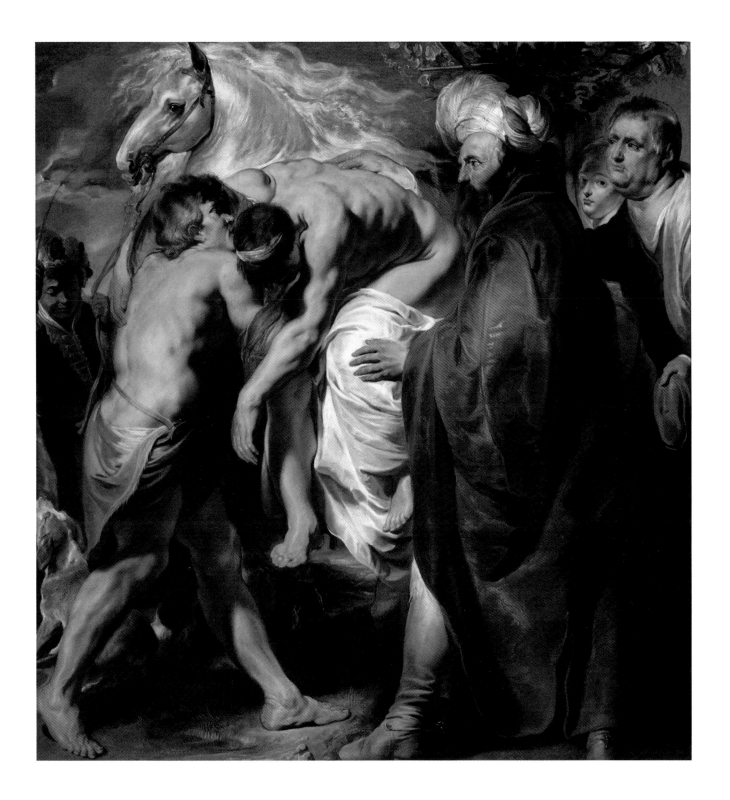

THE GOOD SAMARITAN
Jacob Jordaens (1593–1678)
Belgium, Antwerp
1615–16

H. 185.5, W. 173 cm; oil on canvas
LOUVRE ABU DHABI

THE ART OF WAR

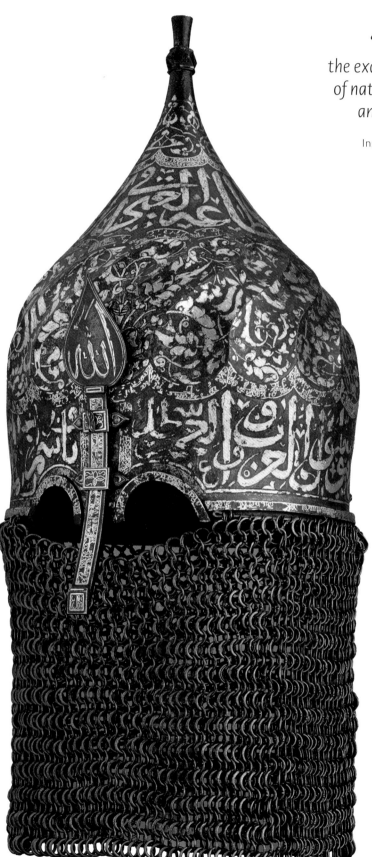

*"The king, the most noble sultan,
the exalted khagan, the master of the highest
of nations, the lord of the kings of the Arabs
and non-Arabs, the shadow of God."*

Inscription on the lower band of text on the helmet

TURBAN HELMET
Turkey
1450–1500

H. 61 cm; steel with silver
inlays, traces of gold
LOUVRE ABU DHABI

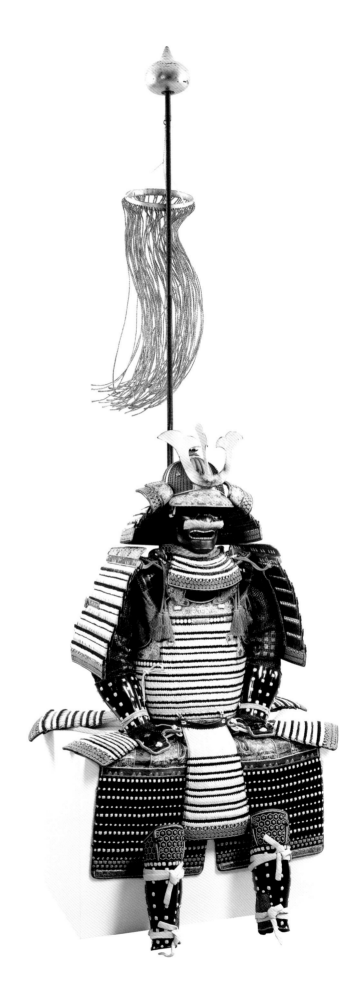

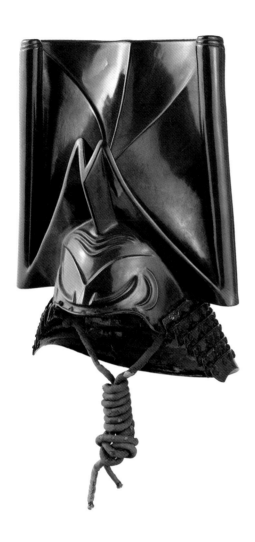

HELMET OF A WARRIOR
Japan
1573–1603

H. 54 cm; lacquer, iron, rope
LOUVRE ABU DHABI

**CEREMONIAL ARMOUR
WITH THE COAT OF ARMS
OF THE SHISHIDO FAMILY**
Japan, Kyoto
1550–1868

H. 270 cm; iron, copper gilt,
lacquered wood, silk, leather
LOUVRE ABU DHABI

THE ART OF WAR

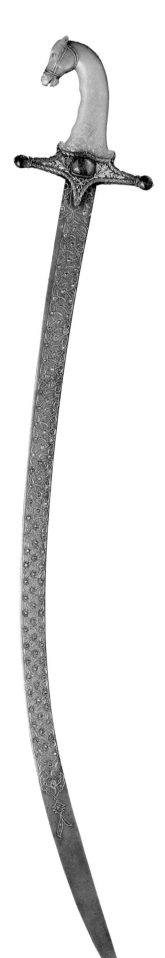

**IMPERIAL CEREMONIAL
SABRE**
Turkey
16th–19th centuries

L. 93 cm; steel, jade, gold
and precious stones
LOUVRE ABU DHABI

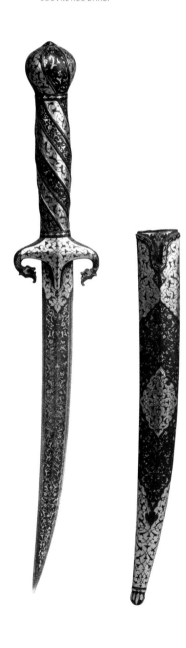

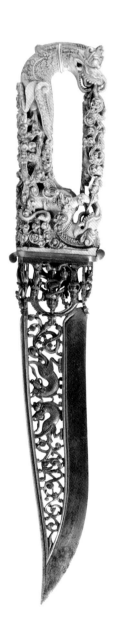

CEREMONIAL DAGGER
Ottoman empire
Turkey
1530–50

H. 26 cm; steel inlaid with gold
LOUVRE ABU DHABI

**ROYAL DAGGER CARVED
WITH HINDU FIGURES**
India
1600–45

H. 35 cm; steel, ivory
LOUVRE ABU DHABI

A NEW ART
OF LIVING

During the 18th century, the affluence enjoyed by monarchs was attained by
an increasingly large segment of society. The spread of manufactured products
around the globe progressively transformed economies and stimulated new
modes of consumption. Greater attention was paid to the furnishing and
decoration of houses and to clothing. In China, Japan and Europe more
manufacturers offered goods to an increasing number of customers. Across
all continents, the arts reflected an increased emphasis on the private sphere,
the individual and the family. With the growth in global exchanges, the arts
developed an imaginative image of remote lands and cultures. Europe was
increasingly pervaded by a philosophy of progress and reason referred to as
the Enlightenment. This intellectual movement focused on the individual and
their role in history, as illustrated by the American and French revolutions at
the end of the century.

THE PRIMACY OF THE PRIVATE SPHERE

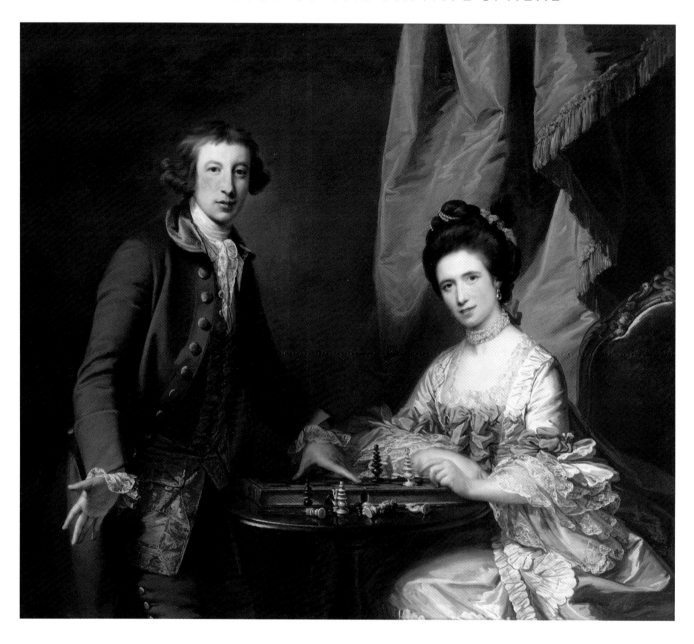

PORTRAIT OF WILLIAM AND PENELOPE WELBY PLAYING CHESS
Francis Cotes (1726–1770)
United Kingdom
1769

H. 135, W. 152 cm; oil on canvas
LOUVRE ABU DHABI

Page 85
COMMODE DECORATED WITH RED LACQUER FROM CHINA (DETAIL)
Bernard II van Risen Burgh (1696–1766)
France, Paris
1753–56

H. 84, W. 116 cm; wood, lacquer, bronze gilt, marble
LOUVRE ABU DHABI

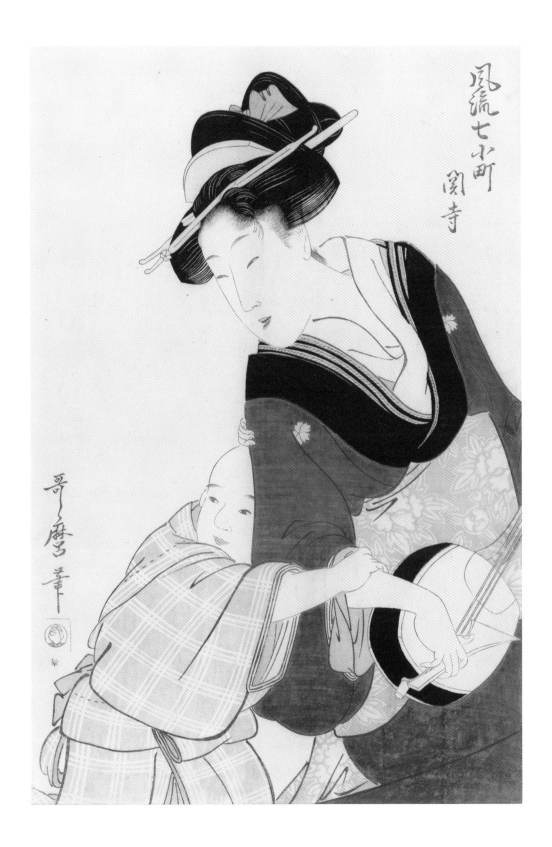

YOUNG MOTHER PLAYING THE SHAMISEN
SERIES OF THE FASHIONABLE SEVEN KOMACHI
Kitagawa Utamaro (1753–1806)
Japan
c. 1798

H. 39, W. 25.7 cm; ink on paper
LOUVRE ABU DHABI

THE FIGURE OF THE HERO

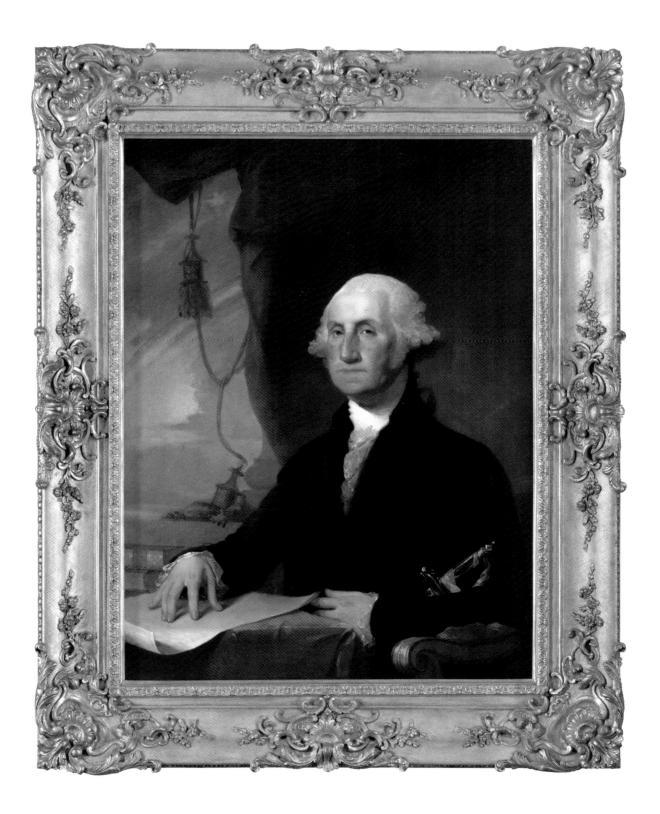

GEORGE WASHINGTON, FIRST PRESIDENT OF THE UNITED STATES
Gilbert Stuart (1755–1828)
United States
1822

H. 164.5, W. 122 cm; oil on canvas
LOUVRE ABU DHABI

Canova's expressive statues
illustrate the inspiration provided
by Antiquity in Western art while
also expressing confidence
in a triumphant future.

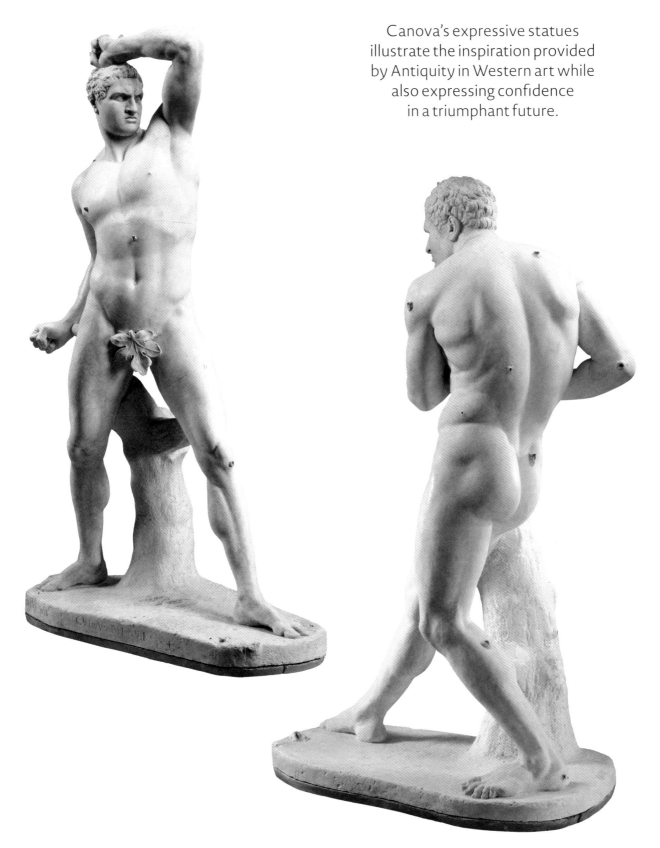

FIGHT BETWEEN CREUGAS AND DAMOXENOS
Antonio Canova (1757–1822)
Italy, Possagno
1797–1803
H. 212 and 205.5 cm; plaster
LOUVRE ABU DHABI

89

VISIONS OF THE ORIENT

PAGE FROM A POLIER ALBUM: ENTERTAINMENTS IN A HAREM
Muhammad Ali
India, Lucknow
1780
H. 45.7, W. 61.5 cm; paperboard, ink, gouache, gold
LOUVRE ABU DHABI

A CHINESE SCENE
Jean-Baptiste Pillement (1728–1808)
France, Paris
1765–67
H. 201.5, W. 230 cm; oil on canvas
LOUVRE ABU DHABI

A MODERN WORLD?

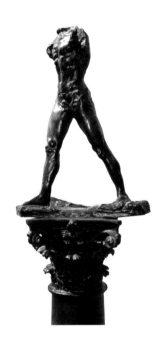

Economic competition between nations gave birth to the Industrial Revolution in Europe. An instrument of Europe's colonial enterprise, this revolution spread progressively to the rest of the world during the 19th century. Colonisation and the development of means of transport impacted all civilisations, which, in return, provided European artists with inspiration. Technical progress and artistic creation were glorified in universal exhibitions. Photography, a product of industry, took on an important role in the art world. By capturing reality and eliminating distance, it gave the individual the impression of taking possession of the world. Since its invention, photography revolutionised artistic creation, prompting painters in Europe, then around the world, to drastically alter the way they captured images and translated the real world onto canvas.

THE BIRTH OF PHOTOGRAPHY

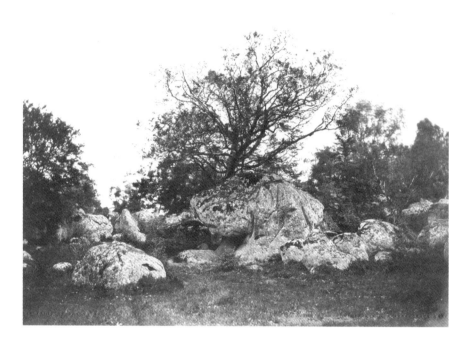

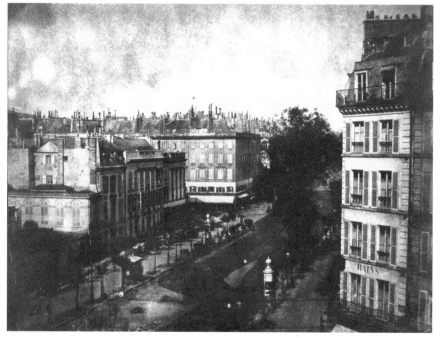

Page 91
**WALKING MAN,
ON A COLUMN**
Auguste Rodin (1840–1917)
1900

H. 3.57 m; bronze, lost-wax cast
made in 2006, Fonderie Coubertin
LOUVRE ABU DHABI

**ROCKS, FONTAINEBLEAU
FOREST**
Gustave Le Gray (1820–1884)
France, Fontainebleau
c. 1852

H. 27.9, W. 35.8 cm; salt print,
made from a paper negative
LOUVRE ABU DHABI

**THE BOULEVARDS
OF PARIS**
William Henry Fox Talbot
(1800–1877)
France, Paris
May 1843

H. 16.3, W. 21.5 cm; salt print
LOUVRE ABU DHABI

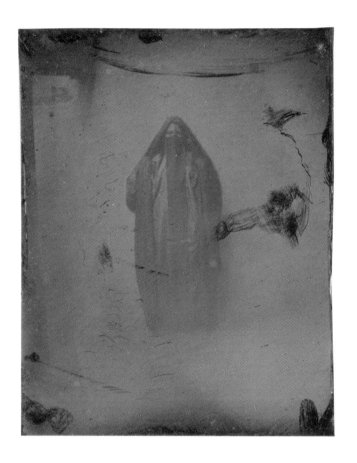

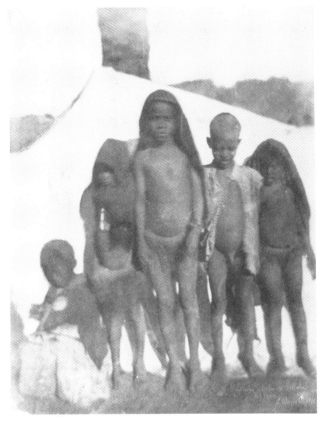

AYOUCHA
Joseph-Philibert Girault de Prangey (1804–1892)
Egypt, Cairo
1843
H. 12.1, W. 9.8 cm; daguerreotype
LOUVRE ABU DHABI

GROUP OF FELLAH CHILDREN AT ESNEH
Ernest Benecke (1817–1894)
Upper Egypt
20 February 1852
H. 21.4, W. 16.4 cm; salt print, made from a paper negative
LOUVRE ABU DHABI

THE PAINTERS OF MODERN LIFE

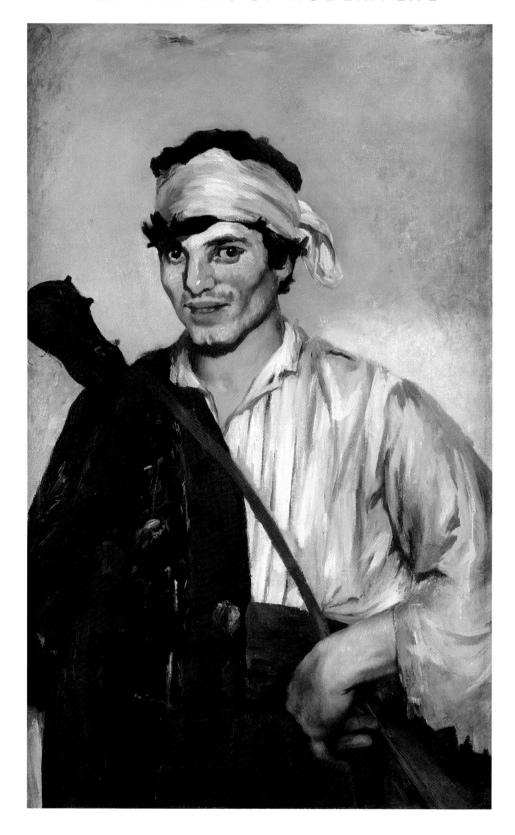

THE BOHEMIAN
Édouard Manet (1832–1883)
France, Paris
1861–62 (cut out in 1867)
H. 90.5, W. 55.3 cm; oil on canvas
LOUVRE ABU DHABI

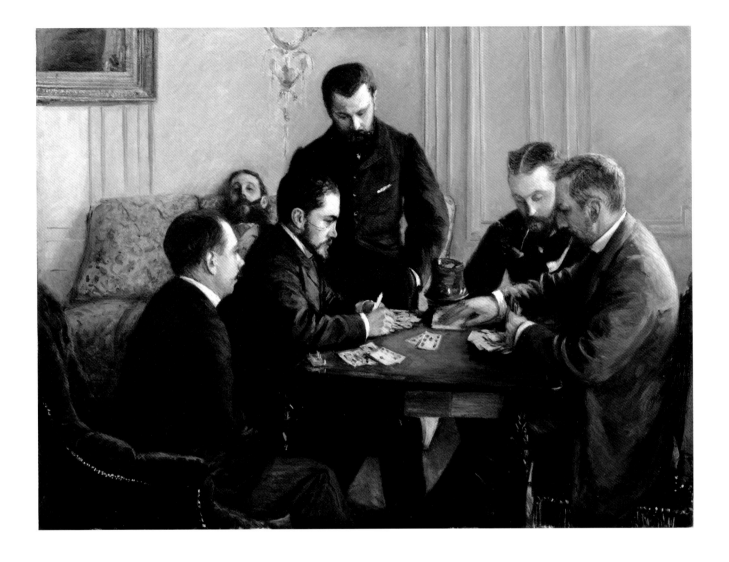

In a society undergoing rapid change
and confronted by the sudden
appearance of photographic images,
portraiture became the quintessential
modern subject for artists.

The Bezique Game
Gustave Caillebotte (1848–1894)
France, Paris
1880

H. 125.3, W. 165.6 cm; oil on canvas
LOUVRE ABU DHABI

95

ORIENTALISM AND OCCIDENTALISM

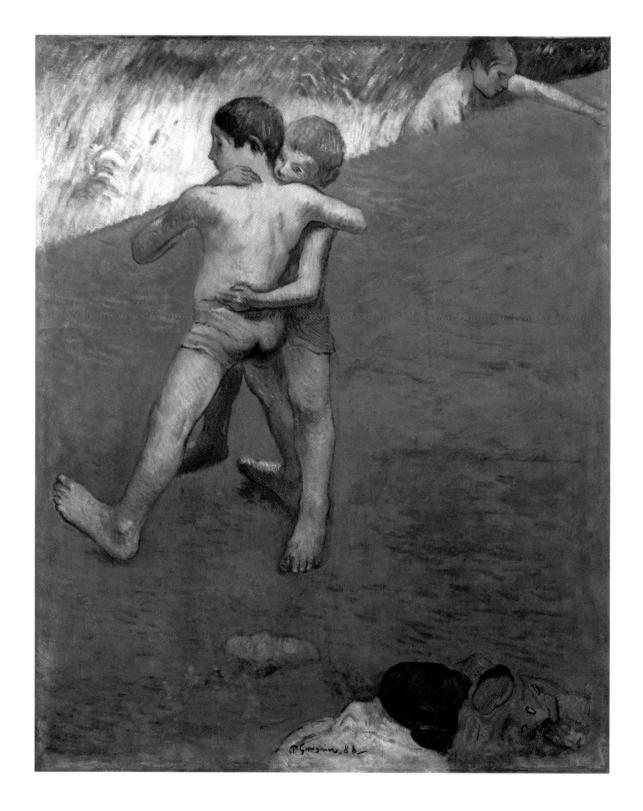

CHILDREN WRESTLING
Paul Gauguin (1848–1903)
France, Pont-Aven
1888

H. 93, W. 73 cm; oil on canvas
LOUVRE ABU DHABI

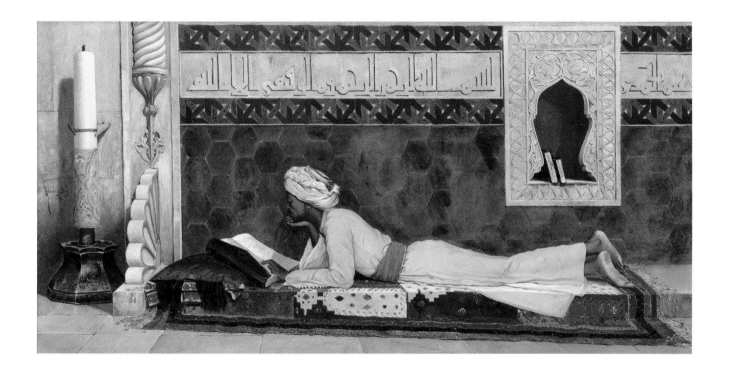

YOUNG EMIR STUDYING
Osman Hamdi Bey (1842–1910)
Turkey, Istanbul (?)
1878

H. 45.5, W. 90 cm; oil on canvas
LOUVRE ABU DHABI

JAPAN AND JAPONISM

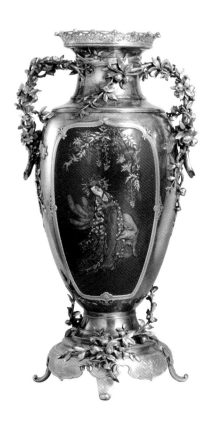

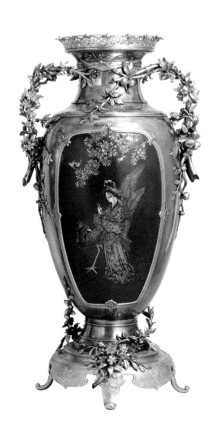

**PAIR OF VASES IN
JAPANESE STYLE**
Émile-Auguste Reiber
(1826–1893),
Maison Christofle & Cie
France, Paris and Saint-Denis
c. 1880

H. 97 cm; bronze, copper,
painted decoration
LOUVRE ABU DHABI

**ANGLO-JAPANESE
"SMALLHYTHE"
FOLDING TABLE**
Edward William Godwin
(1833–1886)
United Kingdom, London
1872

H. 74.7 cm; stained wood, brass
LOUVRE ABU DHABI

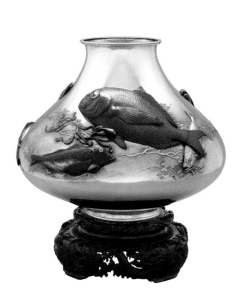

**VASE WITH FISH
DECORATION**
Tsukada Shukyo (1848–1918)
Japan
1910

H. 24.7 cm; silver with
metal inlays, wood
LOUVRE ABU DHABI

**TOTO ASUKAYAMA,
FROM THE SERIES THIRTY-SIX
VIEWS OF MOUNT FUJI**
Utagawa Hiroshige (1797–1858)
Japan
1858

H. 34.6, W. 23 cm; ink and colour on paper
LOUVRE ABU DHABI

**MUSASHI TAMAGAWA,
FROM THE SERIES THIRTY-SIX
VIEWS OF MOUNT FUJI**
Utagawa Hiroshige (1797–1858)
Japan
1858

H. 34.6, W. 23 cm; ink and colour on paper
LOUVRE ABU DHABI

AFRICA AND OCEANIA

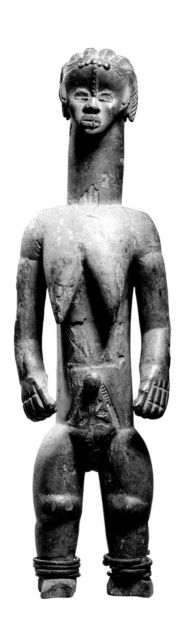

STATUE
Côte d'Ivoire, Haut-Cavally
1800–1900

H. 61 cm; wood, nails, iron
LOUVRE ABU DHABI

ULI STATUE,
ANCESTOR FIGURE
Papua-New Guinea, New Ireland
1700–1900

H. 126 cm; painted wood
LOUVRE ABU DHABI

CHALLENGING
MODERNITY

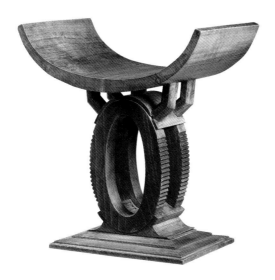

During the 20th century, the notions of modernity and progress, which the industrial and colonial West had spread across the planet, were brought into question. The two world wars and many instances of decolonisation challenged a great number of certainties. Artistic creation reflected these developments, experiencing constant reinvention, punctuated by divisions and radical movements such as abstraction, readymades and the imaginative universe of the Surrealists. Echoing the remarkable pace of modern life, the rapid succession of artistic movements constantly opened new perspectives. The boundaries of art were continually redefined, extended and in constant transformation. The avant-garde movements in Paris and elsewhere in Europe attracted artists from all over the world. The growing influence of North American artists coincided with the broadening of artistic horizons to encompass the world as a whole.

THE NEW DECORATIVE ART

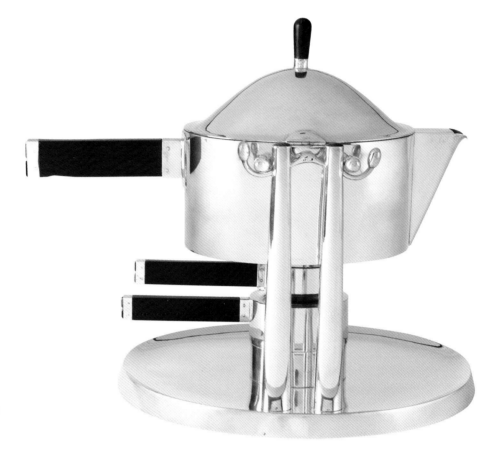

SAMOVAR
Josef Hoffman
(1870–1956) (silversmiths:
J. Hoszfeld and J. Holi)
Austria, Vienna
1904–05
H. 31.5 cm; silver, wood, coral, onyx
LOUVRE ABU DHABI

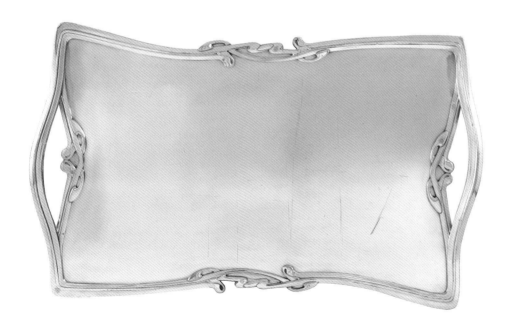

TRAY
Henry Van de Velde (1863–1957)
Belgium, Brussels
1898
H. 69.3, W. 41.7 cm; silver-plated bronze
LOUVRE ABU DHABI

Page 101
**CURULE SEAT
IN AFRICAN STYLE**
Pierre Legrain (1889–1929)
France, Paris
c. **1925**
H. 53 cm; beech stained
to resemble walnut
LOUVRE ABU DHABI

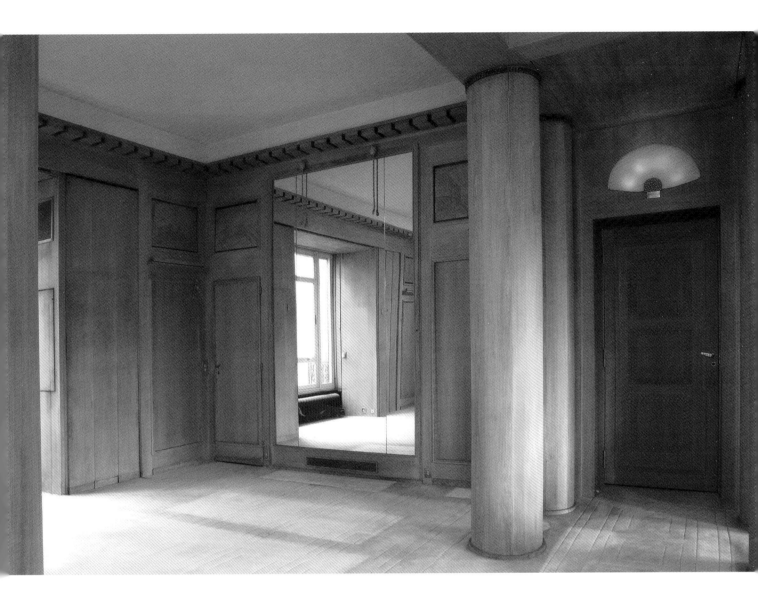

**THE SALON-DINING
ROOM OF LORD
ROTHERMERE**
Jacques-Émile Ruhlmann
(1879–1933)
France, Paris
1925
70 m², H. 308 cm; wood, mirrors, fittings
LOUVRE ABU DHABI

LOW RELIEF
Louis-Pierre Rigal (1888–1959)
France, Paris
1925
Wood
LOUVRE ABU DHABI

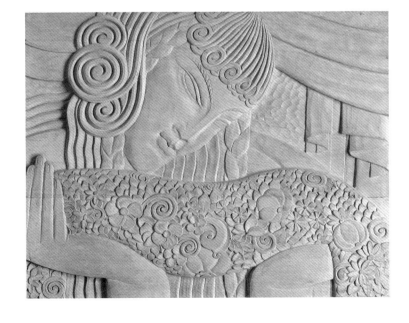

A TOTAL ART

"Free colour from form."

František Kupka

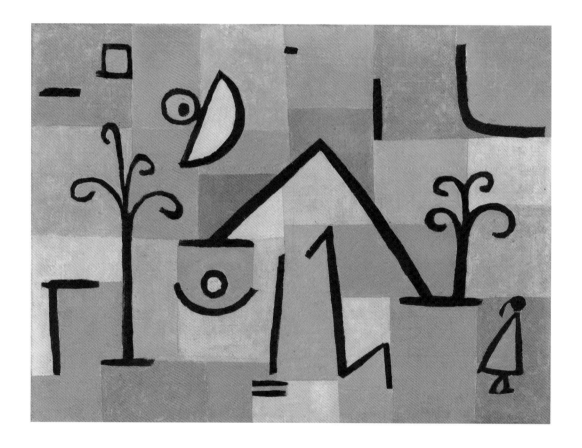

ORIENTAL BLISS
Paul Klee (1879–1940)
Switzerland, Berne
1938
H. 50, W. 66 cm; paint on paper stuck on canvas
LOUVRE ABU DHABI

CRYSTAL
František Kupka (1871–1957)
France, Puteaux
1919–20

H. 73, W. 86 cm; oil on canvas
LOUVRE ABU DHABI

THE QUEST FOR A UNIVERSAL LANGUAGE

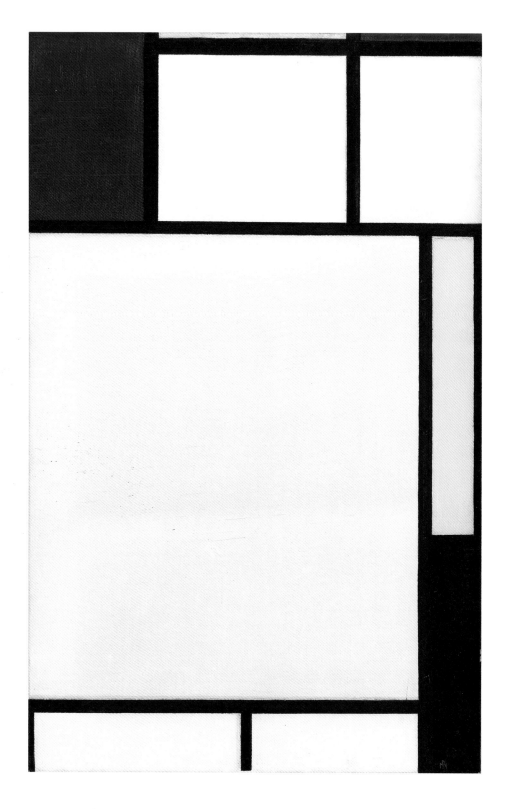

COMPOSITION WITH BLUE, RED, YELLOW AND BLACK
Piet Mondrian (1872–1944)
France, Paris
1922
H. 79.8, W. 50 cm; oil on canvas
LOUVRE ABU DHABI

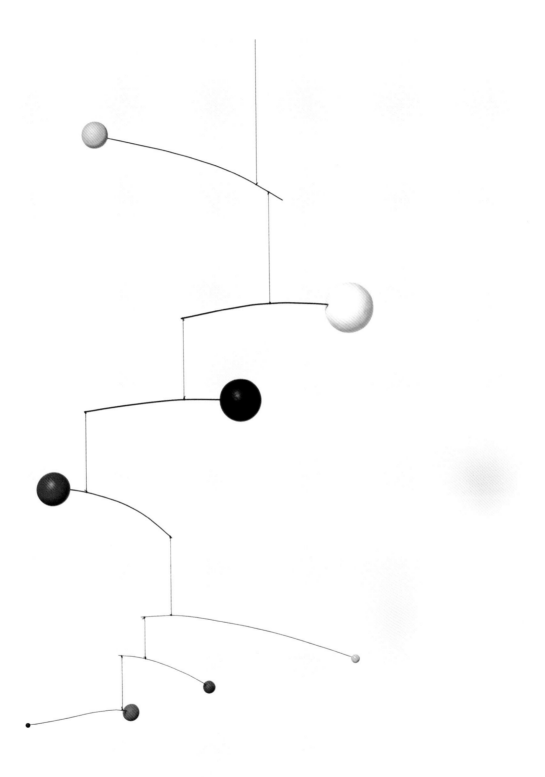

Mobile – Untitled
Alexander Calder (1898–1976)
United States, New York
c. 1934

H. 62.9 cm; metal rods, painted wood
LOUVRE ABU DHABI

DREAMS AND LIFE

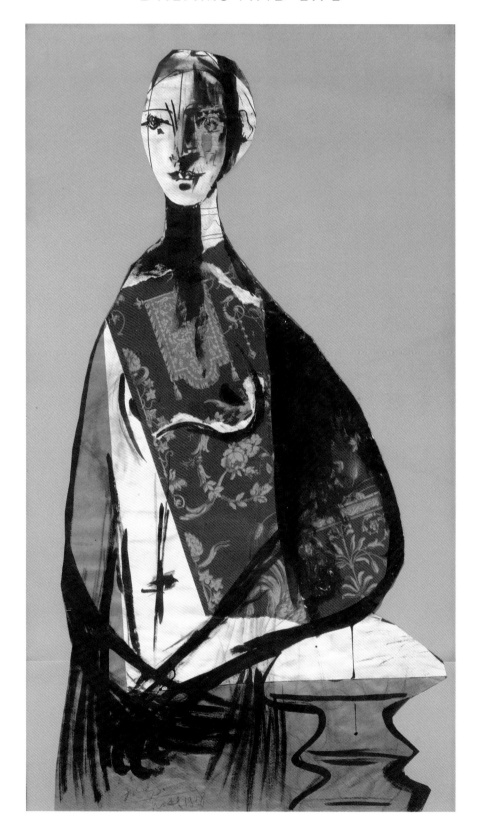

PORTRAIT OF A WOMAN
Pablo Picasso (1881–1973)
1928

H. 119, W. 60 cm; gouache, India ink and painted paper glued on paper
LOUVRE ABU DHABI

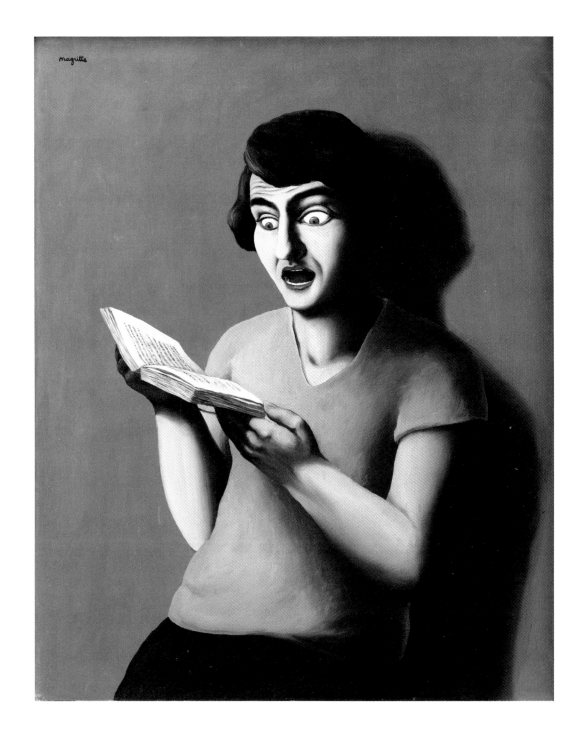

THE SUBMISSIVE READER
René Magritte (1891–1967)
France, Le Perreux-sur-Marne
1928

H. 92, W. 73.5 cm; oil on canvas
LOUVRE ABU DHABI

GEOMETRIC ABSTRACT ART

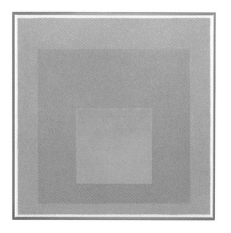

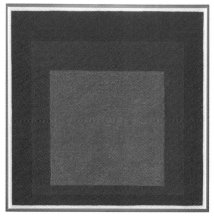

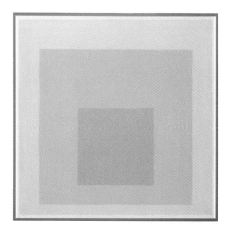

STUDY FOR HOMAGE TO THE SQUARE: WITH AURA
Josef Albers (1888–1976)
United States
1959
H. 45.7, W. 45.7 cm; oil on fibreboard
LOUVRE ABU DHABI

HOMAGE TO THE SQUARE
Josef Albers (1888–1976)
United States
1963
H. 45.7, W. 45.7 cm; oil on fibreboard
LOUVRE ABU DHABI

STUDY FOR HOMAGE TO THE SQUARE
Josef Albers (1888–1976)
United States
1963
H. 45.7, W. 45.7 cm; oil on fibreboard
LOUVRE ABU DHABI

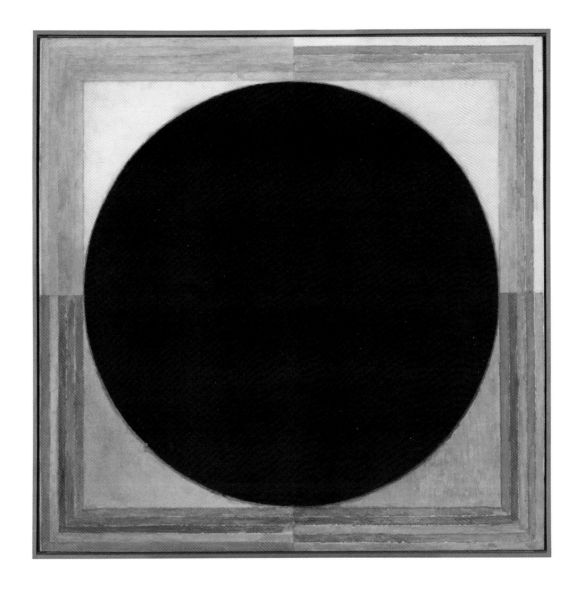

Bindu
Sayed Haider Raza (1922–2016)
France or India
1986

H. 120.4, W. 120.4 cm; acrylic on canvas
LOUVRE ABU DHABI

A DISTANT GAZE

**AFRICAN NEGRO
ART PORTFOLIO**
Walker Evans (1903–1975)
United States, New York
1935
Silver gelatin print
LOUVRE ABU DHABI

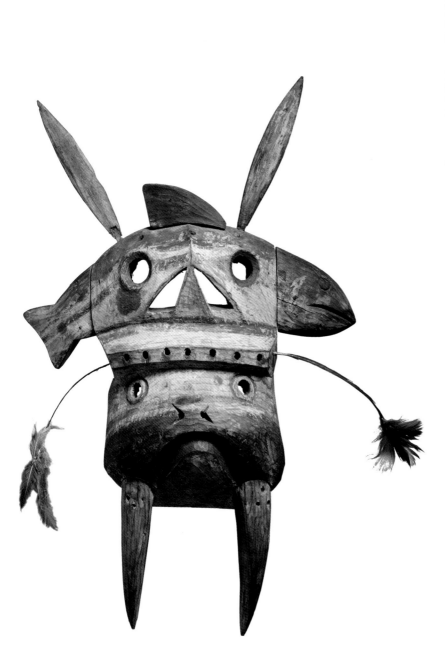

**SHAMANIC RITUAL
MASK**
Yup'ik culture
Alaska
1890–1910
H. 58, W. 37 cm; wood, natural
pigments, plant fibres, feathers
LOUVRE ABU DHABI

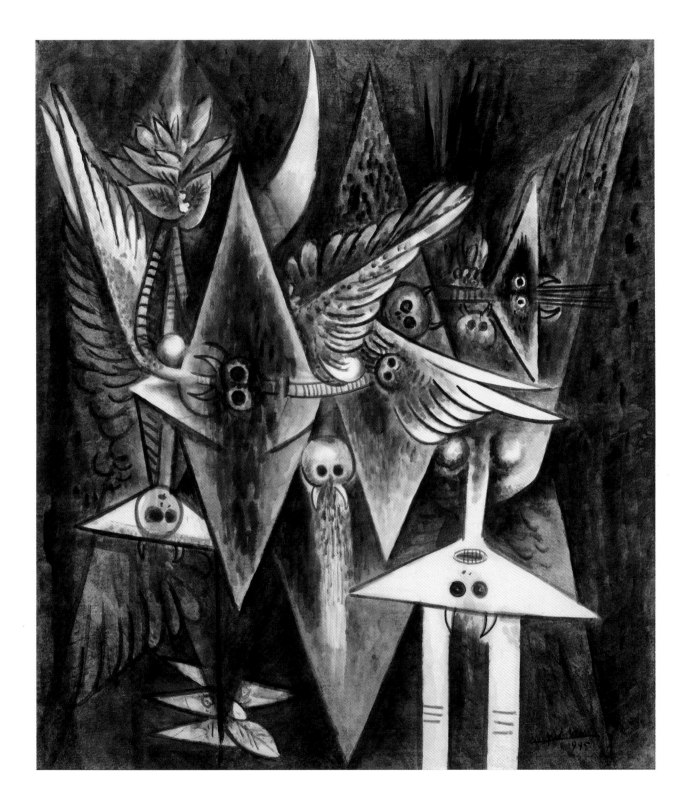

The Antillean Parade
Wifredo Lam (1902–1982)
Cuba
1945
H. 125.5, W. 110 cm; oil on canvas
LOUVRE ABU DHABI

ACTION PAINTING AND PERFORMANCES

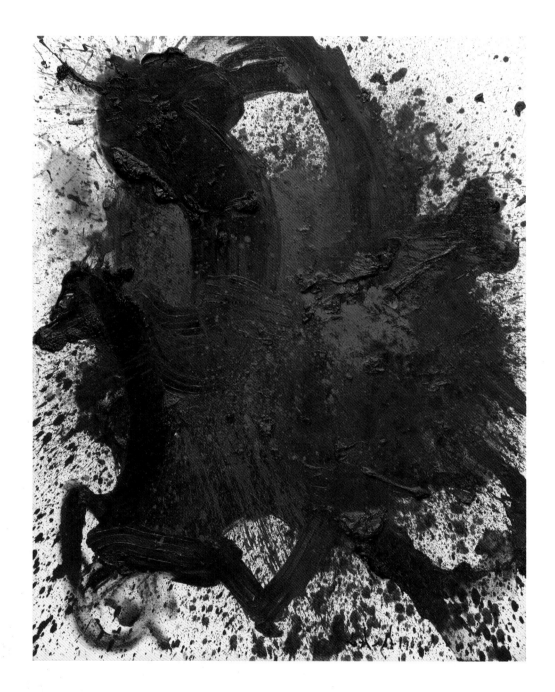

CHIRISEI KYUBIKI
Kazuo Shiraga (1924–2008)
Japan
1960

H. 160, W. 130 cm; oil on canvas
LOUVRE ABU DHABI

UNTITLED ANTHROPOMETRY (ANT 110)
Yves Klein (1928–1962)
France, Paris
1960

H. 212.9, W. 157.9 cm; paint on paper mounted on canvas
LOUVRE ABU DHABI

114

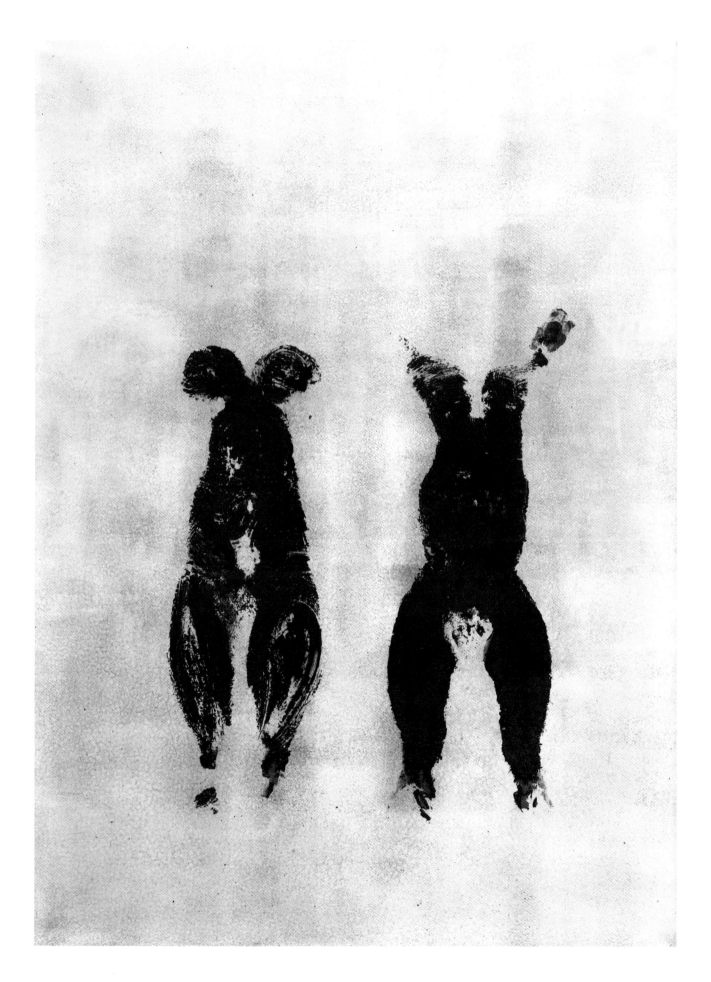

THE POETICS OF THE MECHANICAL

PRESSE "ORANGE A+B"
Jean Tinguely (1925–1991)
France
1960

H. 120 cm; metal, tricycle,
wheels, orange juicer, bucket,
wood, motor, fabric, wire
LOUVRE ABU DHABI

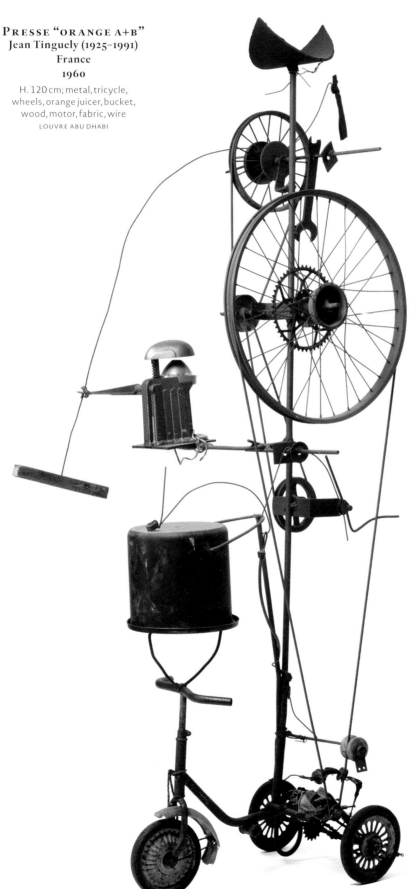

Part surrealist invention
and part enhanced readymade,
this work raises the question
of the place
of the machine and
the object in 20th-century
sculpture.

A GLOBAL STAGE

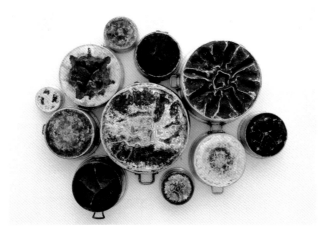

At the beginning of the 21st century, the scale of communications around the globe seems to have transformed the planet into a global village. The last decade of the 20th century marked the end of a historical era in which the West had occupied centre stage. The economic rise of most continents has given way to a multipolar and multicultural world in which artists have taken it upon themselves to invent a different version of modernity. The instant spread and omnipresence of television and internet images place the world in a state of constant self-reflection. Creative works mirror our collective memory stirred by identity issues, the self as a narrative, as well as our concerns about our fragile planet. Artists continue to help us raise or put these existential questions in perspective, as they have done since the dawn of humanity.

ART AND GLOBALISATION

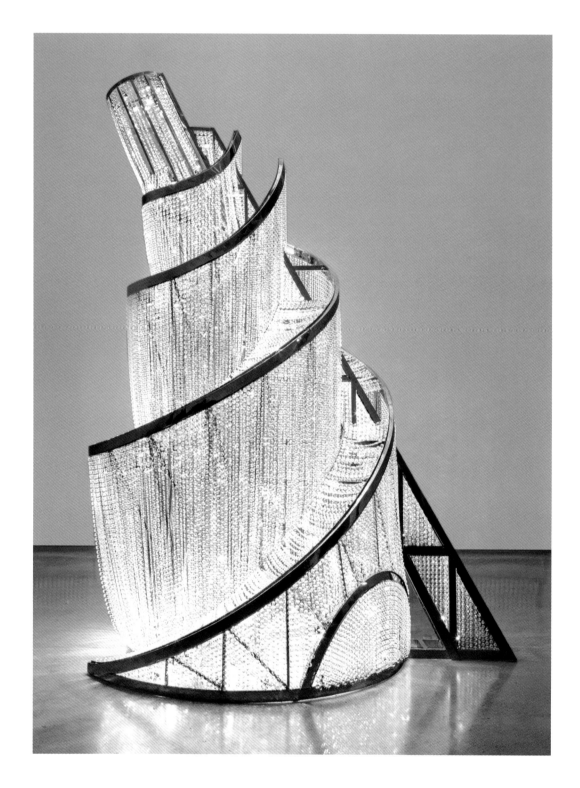

Page 117
**FOOD FOR THOUGHT
– AL MUALLAQAT**
Maha Malluh (1959–)
Saudi Arabia, Riyadh
2013

H. 190, W. 240 cm; eleven
burned cooking pots
LOUVRE ABU DHABI

FOUNTAIN OF LIGHT
Ai Weiwei (1957–)
Germany, Berlin / China, Beijing
2016

H. 420 cm; steel, glass crystals
LOUVRE ABU DHABI

ACT 1 – DEN
Omar Ba (1977–)
Senegal, Dakar /
Switzerland, Geneva
2016

H. 201.5, W. 130 cm; oil paint,
crayon, India ink, gouache on
corrugated cardboard
LOUVRE ABU DHABI

MULTIPLE REALITIES
Duncan Wylie (1975–)
South Africa, Johannesburg,
and United Kingdom, London
2016

H. 230, W. 300 cm; oil on canvas
LOUVRE ABU DHABI

REVISITING MYTH

1

2 3

THE FUNERAL OF MONA LISA
Yan Pei-Ming (1960–)
France, Ivry-sur-Seine
2008
Polyptych of five panels,
1. and 5. H. 400, W. 400 cm
2. and 4. H. 280, W. 500 cm
3. H. 280, W. 280 cm
Oil on canvas
LOUVRE ABU DHABI

*"Bury the myth in order to revitalize
the act of painting."*

Yan Pei-Ming

4

5

RHYTHMS AND NETWORKS

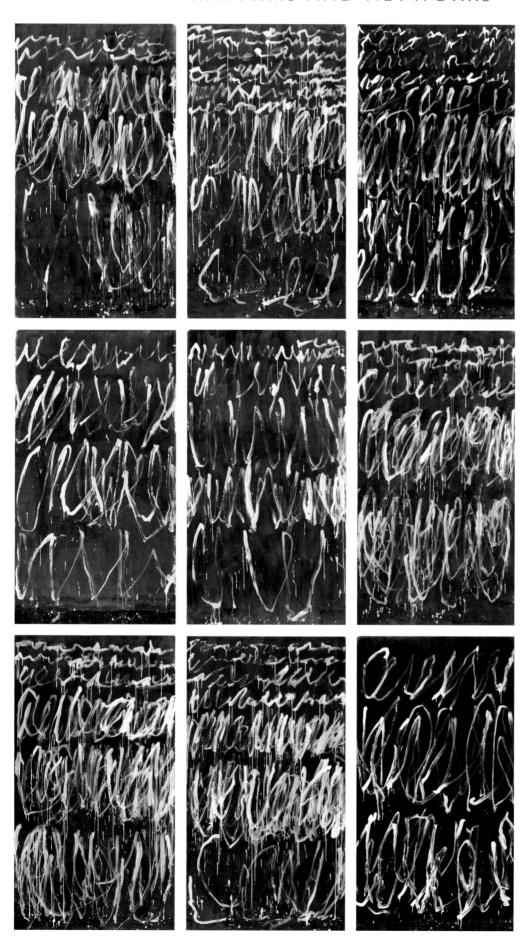

UNTITLED I-IX
Cy Twombly (1928–2011)
2008

Acrylic on canvas
LOUVRE ABU DHABI

UNTITLED I
H. 274, W. 146 cm

UNTITLED II
H. 272, W. 145 cm

UNTITLED III
H. 265, W. 144.5 cm

UNTITLED IV
H. 272, W. 145 cm

UNTITLED V
H. 261.5, W. 144.5 cm

UNTITLED VI
H. 266.2, W. 145 cm

UNTITLED VII
H. 270, W. 145 cm

UNTITLED VIII
H. 267, W. 145 cm

UNTITLED IX
H. 265.4, W. 144.8 cm

*"The line does not illustrate. It is the
sensation of its own realization."*

Cy Twombly

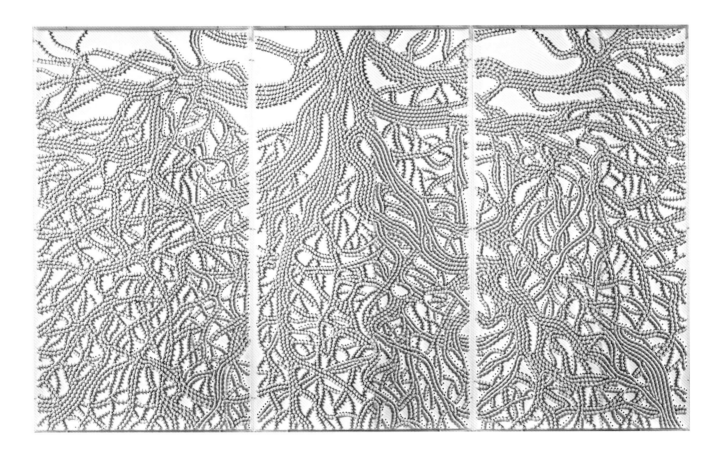

Roots
mounir fatmi (1970–)
France, Paris/Lille
2015–16

H. 120, W. 195 cm; coaxial antenna cable, staples
LOUVRE ABU DHABI

GERMINATION

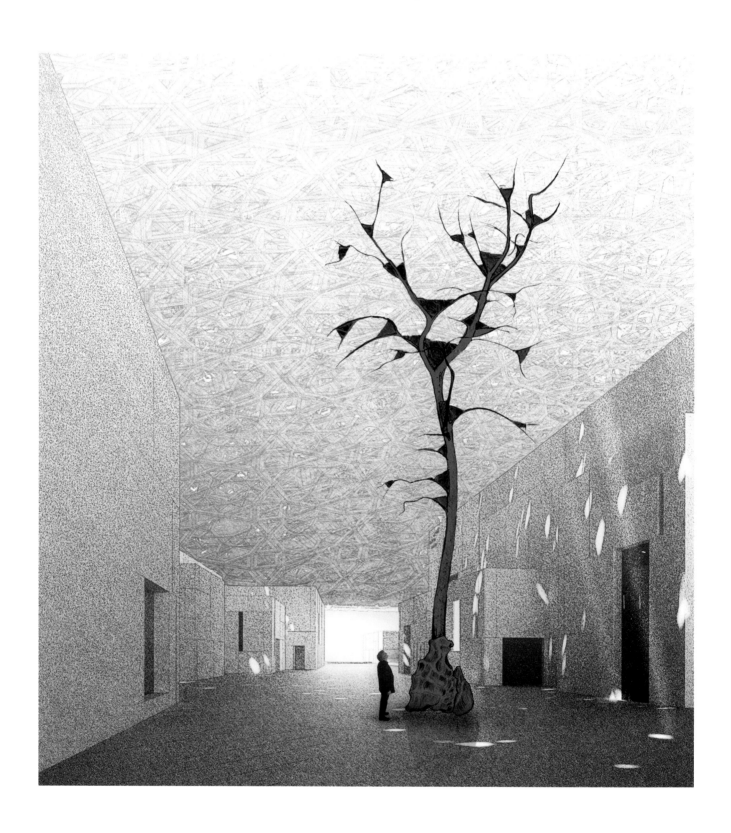

LEAVES OF LIGHT – TREE
Giuseppe Penone (1947–)
Italy, Turin
2016

H. 19 m; bronze; stainless steel
COMMISSIONED BY LOUVRE ABU DHABI

PROPAGATION
(FINAL SKETCH)
Giuseppe Penone (1947–)
France
2016

H. 3.6, W. 4.2 m; drawing on porcelain tiles
Fabrication: Cité de la céramique – Sèvres & Limoges (France)
COMMISSIONED BY LOUVRE ABU DHABI

WRITING THE MUSEUM

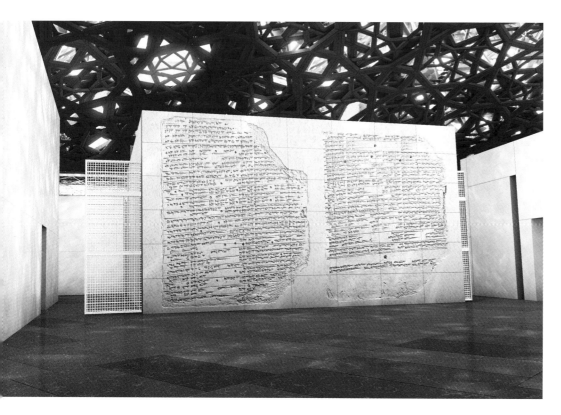

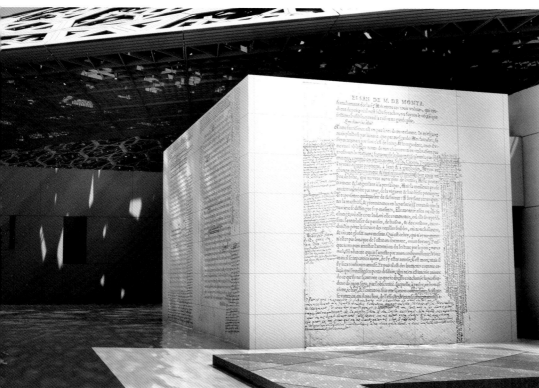

FOR THE LOUVRE ABU DHABI, 2017
Jenny Holzer (1950–)

Marble relief of cuneiform text,
one of the earliest forms of writing,
that transcribes
a creation myth in Sumerian and
Akkadian from a Mesopotamian
tablet, c. 1250 BCE.

H. 7.5, W. 13.5 m
COMMISSIONED BY LOUVRE ABU DHABI

FOR THE LOUVRE ABU DHABI, 2017
Jenny Holzer (1950–)

Limestone relief of three pages printed
and annotated in French, from the
"Bordeaux Copy"
of *Essais* by Michel de Montaigne,
exploring themes of human
nature and writing:
"On Democritus and Heraclitus" (I:50),
"On Conversation" (III:8),
and "On Vanity"(III:9), 1588.

H. 7.50, W. 14 m, and H. 7.50, W. 9 m
COMMISSIONED BY LOUVRE ABU DHABI

FOR THE LOUVRE ABU DHABI, 2017
Jenny Holzer (1950–)

Limestone relief of three pages with
Arabic script from the manuscript
Al Muqqadina by Ibn Khaldun,
a 14th-century Islamic treatise
on the writing of history.

H. 11, W. 11.5 m, and H. 11, W. 6.50 m
COMMISSIONED BY LOUVRE ABU DHABI

"Each man bears within him the entire form
of the human condition."

Michel de Montaigne

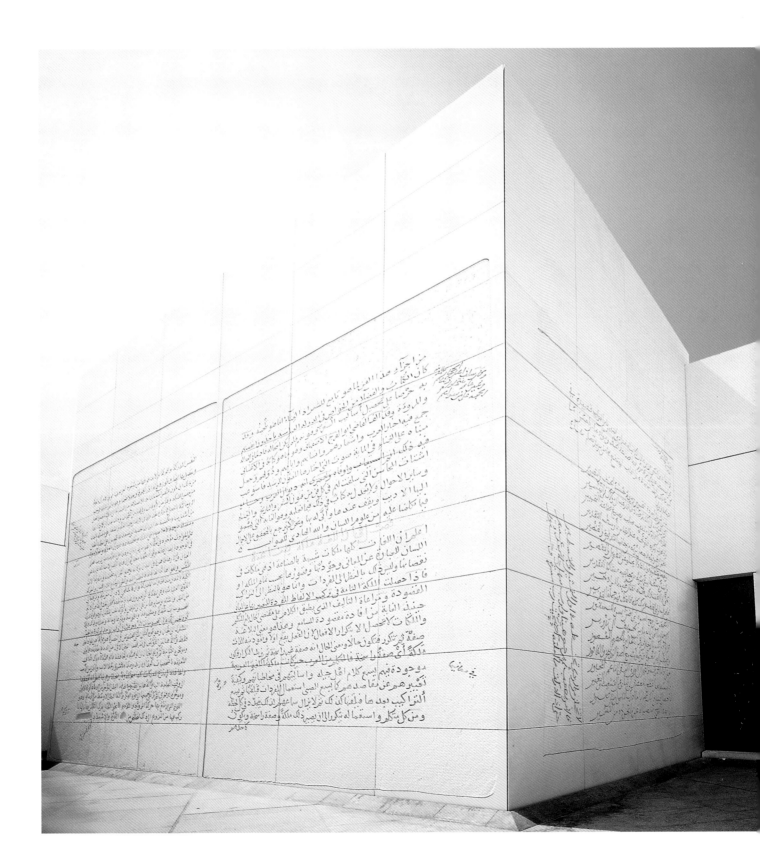

ÉDITIONS SKIRA PARIS
14 rue Serpente
75006 Paris
www.skira.net

Senior Editor
Nathalie Prat-Couadau

Art Director
Marcello Francone

Editorial Coordination
Emma Cavazzini
María Laura Ribadeneira
with Louis Moisan

Copy editor
Timothy Stroud

Design
Prototype – Aurore Jannin
and Laurent Pinon

Layout
Serena Parini

Translations
Paul Metcalfe for *Scriptum*, Rome

Iconographical Research
Paola Lamanna

AGENCE FRANCE-MUSÉUMS
Editorial Direction
Jean-François Charnier

Technical Coordination
Matthieu Thenoz

Editorial Coordination
Elisabeth de Farcy
and Geneviève de La Bretesche

Copyrights

Photo Credits